Edinburgh
MURDERS &
MISDEMEANOURS

David Brandon & Alan Brooke

AMBERLEY

First published 2010

Amberley Publishing Plc
Cirencester Road, Chalford,
Stroud, Gloucestershire, GL6 8PE

www.amberley-books.com

British Library Cataloguing in Publication Data.
A catalogue record for this book is available from the British Library.

ISBN 978 1 84868 173 6

Typesetting and Origination by FONTHILLDESIGN.
Printed in the UK.

Edinburgh
MURDERS &
MISDEMEANOURS

CONTENTS

CHAPTER 1

An Introduction to the History of Edinburgh

Charles Lamb (1775-1834) was an English essayist and poet of some distinction who once said, "I have been trying all my life to like Scotsmen and I am obliged to desist from the experiment in disgust." Sydney Smith (1771-1845), the English man of letters, once quipped that it required a surgical operation to get a joke into a Scotsman's brain. In the same sweepingly general characterisation that makes the French romantic and good lovers, the Welsh musical and Germans militaristic, so the Scots have been derided by the English as humourless, dour and mean. In fact, of course, the Scots are no meaner than anyone else while their humour tends to the sardonic and to a slight debunking of themselves. What people from England often fail to grasp is that Scottish people are generally much prouder of their history and heritage than the average English person. The people of Scotland have much to be proud of. Many of them are rightfully proud of their capital city.

Edinburgh is now and has always been full of contrasts. Surgeons and doctors trained at Edinburgh have had an enormous impact across much of the world and in recent generations they have been frontrunners in such areas as transplant surgery yet less than fifty years ago the city pumped all its sewage, raw and untreated, into the Firth of Forth whereupon much of it washed up on the coast nearby. The city's medical schools and teaching hospitals vie with any in the world and yet Edinburgh has an appalling record so far as heart disease is concerned and the diet of Edinborians is often blamed as a major contributor to the city's poor record on that issue. In the New Town, the city boasts one of the best-preserved examples of early town-planning anywhere in the world and yet there are still bleak housing schemes which are festering pockets of deprivation and despair.

Like Rome, Edinburgh is built on seven hills, most of which are the rumps of ancient volcanoes and she owes her splendid topography and what for many is her beauty precisely to this fact. However her climate is best described as 'robust'. It is raw, especially between mid-October and the end of April and one of the city's most famous sons, Robert Louis Stevenson (1850-94), having described the city's climate as 'one of the vilest under heaven', escaped to more congenial climes. In the dark months

what is known as the 'haar' is a chilling, intensely penetrating wind from the east often accompanied by a freezing fog. Again by way of the contrasts that are a leitmotif for Edinburgh, rainfall is moderate and in mid-summer it can still be light at eleven in the evening.

The ancient name of Edinburgh was Din Eidyn which meant 'Fort of Eidyn'. This evolved into Dunedin and later into Edinburgh. The fort was established on what we now think of as the Castle Rock – one of many volcanic plugs in the vicinity – Arthur's Seat is another - and it originally marked the southern boundary of the Kingdom of Scotland. Edinburgh's dramatic topography is the result of two very different types of geological activity. The first was the volcanic activity just mentioned. The second was glaciation. The volcanic plug of basalt on which the castle stands was gouged and scraped by ice caps moving generally in a southerly direction. They account for the steep sides of the Castle Rock but that rock itself gave some protection to what is now the hill descending the Royal Mile to Holyrood Palace.

The Romans had a presence in the Edinburgh area because they felt threatened by various Caledonian tribes who frequently marauded down to what is now northern England. Hadrian's Wall was built to contain them but in what might be described as pre-emptive action, the Romans created the sixth British province of Valenta which occupied much of what is now Lothian and Strathclyde. Forts were established at Fisherrow to the east of Edinburgh and at Cramond to the west, the latter being a supply station for the Antonine Wall, a fortified earthwork from the Forth to the Clyde which was probably originally designed as a base from which the Roman army would proceed to tame the Highland Scots, something which they eventually and rather wisely decided not to try.

The Romans occupied the Scottish lowlands in what was probably a kind of uneasy collaboration with the locals. However as everyone knows, troubles at the hub of the endangered empire caused the last Roman soldiers to leave in AD 443 whereupon Scotland for several centuries became a battle ground between the locals who were collectively known as Picts and the Saxons based in Northumbria. It was probably in 682 that an earlier fort on the hill overlooking the present-day city of Edinburgh was rebuilt in stone by King Edwin of Northumbria to mark the northern extent of his kingdom. What we now think of as the Castle Rock came to be seen as a centre of relative security in a turbulent land and a clutter of huts and simple dwellings grew up in its lee. By 854 this settlement had grown sufficiently for the English bishopric of Lindisfarne to decide that a small chapel should be erected to preach the word to the local population and this was dedicated to St Giles. Gradually Picts and Scots came to an accord and they united to create a kingdom of the Scots but over the following period, they held court at Scone in Perthshire or at Dunfermline, both locations being safely beyond the Firth of Forth, a formidable obstacle to any force moving north with hostile intent.

It was only in 1018 that Scotland under King Malcolm I was able to assert itself sufficiently to push the country's borders southwards as far as the River Tweed when he inflicted a very heavy defeat on the Northumbrians. In 1068, King Malcolm III and his wife, Margaret who was the grand-niece of Edward the Confessor, decided to build a royal palace on the highly defensible outcrop now known as the Castle Rock. A chapel erected within the Castle precincts from this time survives as the oldest building in Edinburgh.

King David came to the Scottish throne in 1107 and he created a little medieval walled town on the eastern slopes of the hill rising to the castle and it reached from the castle to where the High Street and the South Bridge now intersect. No trace of this town wall survives which is perhaps not surprising because it was built only of turf and earth with wooden gates surmounted by spikes.

Edinburgh began to be one of the main centres of the Scottish court and the town became a royal borough and an increasingly important commercial and administrative centre. The small chapel of St Giles was substantially rebuilt and some traces of the building work of this time can still be seen. This process of growth was assisted in 1128 when Holyrood Abbey was established at the foot of the hill leading up to the Castle Rock. It was a large monastic community and as so often happened with such places, it attracted businesses to keep it supplied and a workforce to do the jobs that the brethren themselves could not do. As the abbey prospered, the community around it became known as Canongate and such was the clout of the abbey that Canongate became a borough in its own right. The abbey was said to have been founded because King David chose to go out hunting on a holy day when such frivolous activities were prescribed. He was attacked by a wounded and angry stag which knocked him off his horse and would doubtless have trampled him to death had not a cross suddenly appeared between its antlers. This apparently caused it to stop harassing the king who was so grateful for what he regarded as divine intervention that he decided there and then to found an abbey and the crest of the Burgh of Canongate adopted a cross and a stag's head.

Robert the Bruce granted Edinburgh a new royal charter in 1329 which gave it jurisdiction over the port of Leith about two miles away down the hill from the castle. It had been Robert the Bruce who, in defeating the English so decisively at Bannockburn, established Scotland's nationhood but the town of Edinburgh continued to be captured by the English, burnt and sacked and then retaken by the Scots, with almost monotonous regularity. Leith developed a busy trade with countries around the Baltic Sea and in Scandinavia and this brought considerable prosperity to Edinburgh; enough to enable it to build much more substantial defensive walls and set itself up as the permanent capital of Scotland. Under the rule of King James IV (1473-1513), the city enjoyed a brief blossoming in the Renaissance and during this time a royal palace was built at Holyrood alongside the abbey and a royal charter was granted to

the College of Surgeons, this being evidence that the city even then was developing as a centre of culture and learning. Many other prestigious professional and academic bodies would be established in Edinburgh over the centuries to come. A particular high spot came in 1503 when James married Margaret Tudor, daughter of Henry VII in a glittering pageant at Holyrood. James, dressed in a jacket of crimson velvet trimmed with cloth of gold, met his new bride at Dalkeith and escorted her in a great procession to Edinburgh where the houses were covered in tapestry and a fountain ran with wine.

Edinburgh's success and growth rested on two developments; its growing domination of the export trade from Scotland since Berwick-upon-Tweed had been lost to the English in 1334; and its status as a capital from the reign of James III (1460-1488) onwards. For example by the 1590s, 90% of Scottish wool was being exported through the port of Leith. The city was wealthy but real affluence was confined to the top 5% of the city's population. Most of them were in some way involved with foreign trade or as leading lights in the craft and trade guilds. From the sixteenth to the eighteenth century, the city was the centre of numerous industries such as breweries, dye works and paper mills.

These heady days ended abruptly in 1513, at least temporarily, with the appalling defeat suffered by the Scots at the Battle of Flodden which opened up a period of great political instability. King James had been answering a call for assistance from the old ally, France and he marched the largest Scottish army ever towards England only for it to be totally annihilated. This rekindled fears of yet another invasion by the English and so the 'Flodden Wall' started to be built. This was 18 feet high, 5 feet thick and had six well-defended gates or 'ports' as they were called. It eventually enclosed an area of roughly 140 acres and included such districts as the Cowgate and Grassmarket which had been suburbs outside the previous town walls. The Flodden Wall ran due south from the castle across the western end of the Grassmarket where the West Port was situated. It continued south up the alley known as the Vennel where the best preserved piece of it can still be seen. It then turned east to the Greyfriars Kirk and another gate, the Bristo Port where the present-day Bristo Place and Forrest Road meet. It then ran past the Royal Scottish Museum to the Pleasance where another fragment remains. Going north it crossed the High Street at the Netherbow Port, the main gate to Edinburgh and it then turned west to abut the Nor' Loch and end somewhere under the modern North Bridge.

Enclosed within its walls, Edinburgh felt rather more secure than before and as its prosperity developed, some grand buildings were erected. Some can still be seen such as Bishop Bothwell's House and John Knox's House but the population grew and grew within the limited space available and became grossly overcrowded. It was also during the sixteenth century that St Giles Kirk developed into the splendid building we can now see.

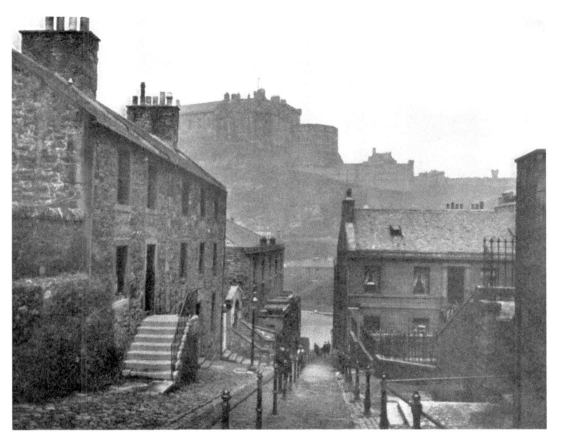

The Vennel off the Grassmarket is a narrow street in which can be seen the last visible remnants of the city's walls.

In the 1540s, King Henry VIII's determination to wed his son Edward to Mary Stuart, otherwise known as Mary, Queen of Scots, led to the English carrying out a scorched earth type of invasive warfare ironically called 'The Rough Wooing'. English forces ranged through lowland Scotland burning, looting, robbing, raping and murdering and they eventually sacked Edinburgh itself. This humiliation prompted the Scots to turn to France for assistance. This was something which the French were only too happy to do against the old enemy and French troops guarded the city while the young Mary was dispatched to Paris to become the bride of the effete Dauphin. The French military presence may have seen the English off but the native Scots did not like the strutting triumphal ways of the French and this probably helped to push them in the direction of the Protestant Reformation. When John Knox returned from exile in 1555, his anti-Catholic message found huge numbers of adherents in lowland Scotland.

In 1582 King James VI founded Edinburgh University but dog days were to follow following his accession of the English throne. It was as if he couldn't wait to get out of Scotland and Edinburgh in particular and the city found itself totally upstaged by London. James had left solemnly promising that he would return at least every three years but it was not until 1617 that he made his solitary return trip. In 1633 Charles I visited Edinburgh for his coronation by way of a bit of public relations work but soon afterwards he reversed the effect and created a crisis by introducing bishops to the Church of Scotland, and making Edinburgh the seat of a bishop. Edinburgh became a city at the same time.

Fifty years of bitter religious dissension and squabbling followed culminating in the establishment of Scottish Presbyterianism. By the mid-seventeenth century, Edinburgh was growing fast and being constrained within the Flodden Walls, it had little choice but to grow upwards, towering tenements being built in the High Street; but also having many dwellings which were literally carved out underground. In the seething mass of buildings, people, smells and activity that was the Old Town, rich and poor lived cheek by jowl. Edinburgh can truly be aid to be the place where the high rise building first saw the light of day. In 1700 a devastating fire caused the city burghers to require future buildings to be made of stone. To the north of the High Street on much lower ground was the Nor' Loch where the Waverley Station now is and this was becoming increasingly unsavoury as it was used as a convenient dumping ground for the rubbish and detritus of the teeming hordes in the streets above. The town was ravaged by epidemic diseases such as plague (for the last time in 1648), cholera and typhus. Edinburgh was dangerous and filthy and it stank.

In 1637 when the new English litany drawn up by Archbishop Laud was read in church for the first time, Jenny Geddes, an Edinburgh market stallholder, threw her stool at the preacher to express the outrage that she and so many others felt and within a year all lowland Scotland was up in arms. The National Covenant declaring support for the Presbyterian Church had been signed in Greyfriars Kirk and forces of Covenanters were ranging across the country attacking any castles and other places associated with the English.

In 1650 Cromwell's forces attacked Edinburgh but were repulsed. He then won the Battle of Berwick and was able to enter the city unchallenged, establishing martial law. During the period of the Commonwealth, his right-hand man, General Monck ruled the city with a rod of iron and the stability that ensued enabled the city to enjoy a period of considerable prosperity. However, Edinborians were elated when Charles II returned to the throne in 1660 – a Stuart was back on the throne! Charles of course was followed by the fervently Catholic James II of England who was unpopular north of the border. For this reason, most Scots welcomed the accession to the throne of William and Mary.

The Union of the Scottish with the English Parliament in 1707 dealt a further blow to Edinburgh's political prestige though Scotland managed to retain control of

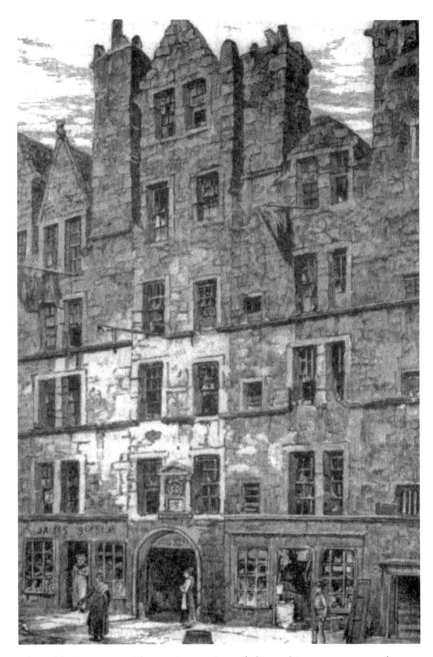

This old picture provides an impression of the multi-storey nature of many of the Old Town's buildings. While some of these buildings presented, say, six stories to the street, the hilly site which many occupied meant that there were several other stories out of sight from this direction.

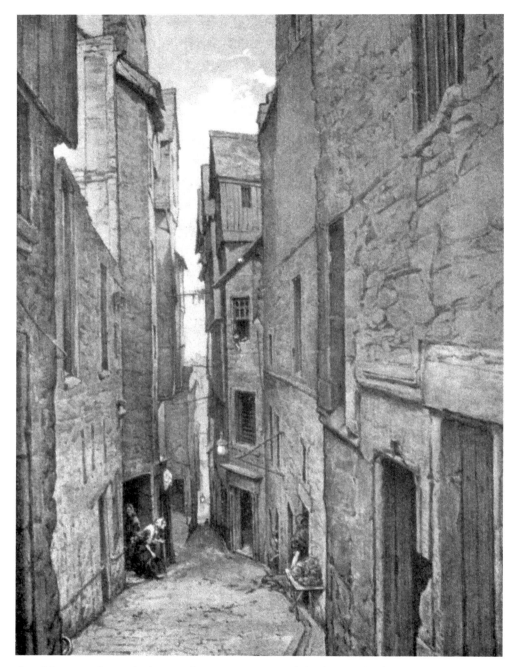

An old watercolour which provides an impression of the labyrinth of alleys and wynds that made up the old part of Edinburgh.

The scene of significant pieces of Edinburgh's history, the kirkyard contains the remains of many eminent Edinborians, both good and bad and a memorial to the Covenanters, huge numbers of whom were executed in the city. A number of mortsafes can be seen. These were heavy cast iron frames placed over graves to prevent their desecration by 'resurrection men'.

its national church, its legal and its educational institutions and Edinburgh went on to carve a niche for itself as a major ecclesiastical, legal and educational centre. The politicians and what we now call civil servants with all their hangers-on, spin-doctors and toadies, left for London, eager to carve out lucrative and prestigious positions for themselves there.

Living standards were undoubtedly lower in Scotland than in England and there were many in Scotland who did not think that the union with England was to their advantage. For that reason it was decided to establish an overseas colony of Scotland's very own at Darien on the Isthmus of Panama from which it was hoped that untold riches in raw materials, trade and commerce, would be forthcoming. The Darien Expedition was an unmitigated disaster. The majority of the ships that set out were wrecked and the small number of would-be settlers who actually got to Darien found only disease, starvation and hostile natives. A huge amount of capital had been invested in the enterprise and almost all of it was lost in a disaster to Scotland's economy which was felt particularly badly in Edinburgh.

This left something of a vacuum which Edinburgh filled by attracting those of a cerebral bent. In the second half of the eighteenth century, Edinburgh achieved the height of its intellectual influence, being an outstanding beacon of the European

Enlightenment. It really was at the cutting edge of the development of ideas. Among its luminaries were David Hume (1711-76), the philosopher and Adam Smith (1723-90), the political economist. Over the following hundred or more years, Edinburgh produced hundreds of people, mostly men it has to be said, eminent in their fields of engineering, science, medicine, literature, art, architecture, mathematics, law, philosophy as well as many leading soldiers and explorers. It was a glorious page in Edinburgh's history.

One final act of stormy Scottish history was still to be acted out on the city's streets. On 15 September 1745 Prince Charles Edward Stuart entered Edinburgh with a force of 2,000 highlanders and remained for about 6 weeks before starting out on his ill-fated invasion of England. The Castle was held by a small garrison of English troops. A rather half-hearted siege took place and a number of citizens were killed or injured in the crossfire but on 31 October 1745 that the castle witnessed its last shots being fired in anger a few hours before the highlanders left for the south.

Within twenty years work began on the building of the New Town to the north of old Edinburgh, a masterpiece of town planning in the neo-classical style and evidence of the wealth and prestige which was accumulating in the city. No other city in the British Isles had such a large proportion of its population employed in the professions. The New Town was planned as an exclusive residential suburb for the rich and prestigious. For this suburb to be created, bridges had to be built across the chasm housing the Nor' Loch and the first of these was North Bridge begun in 1763 the successor to which still straddles the east end of Waverley Station. The residential nature of the New Town was flawed from the start. The first building to be opened was the Theatre Royal and within ten years those houses in the New Town which faced the newly developed east-west Princes Street had become shops. Although this may have damaged the integrity of the plan for a totally residential suburb, later the very fact that the New Town existed at all had an inhibiting effect on the development of the kind of commercial and other buildings normally seen in a Victorian and later on a twentieth-century city centre.

At some time, probably in the late eighteenth century, Edinburgh's apparent physical similarity to Athens was noticed. So Edinburgh, as we would say today, re-branded itself as a city of classical architecture with a crop of buildings on Calton Hill including an incomplete version of the Parthenon and various other Greek-inspired monuments and such neo-classical buildings as the Royal Scottish Academy and the National Gallery of Scotland on The Mound. This road was developed as another route joining the Old Town with the New Town to the north.

Those who could afford to, got out of the Old Town and moved to the more salubrious surroundings of the New Town or elsewhere. Others who continued to live there mostly did so because they basically had no option. The fact is that the Old Town became an appalling gigantic and sinister slum in which every so often epidemic diseases such as

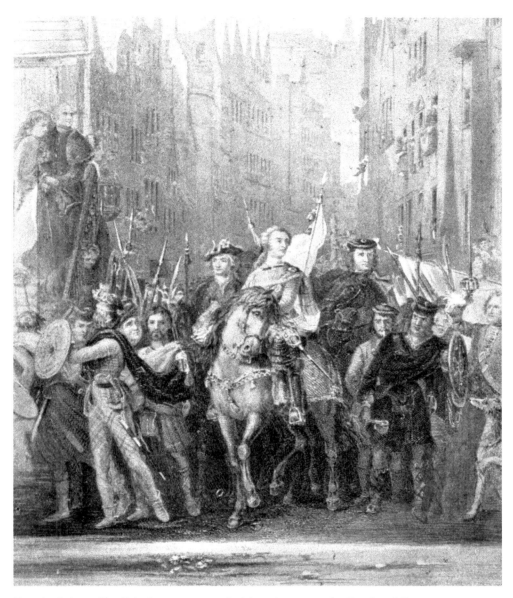

Bonnie Prince Charlie's forces won a decisive victory at the Battle of Prestonpans on 21 September 1745. A couple of days later he entered Edinburgh displaying many items such as regimental banners seized from the British troops. The crowd gave him a tumultuous welcome.

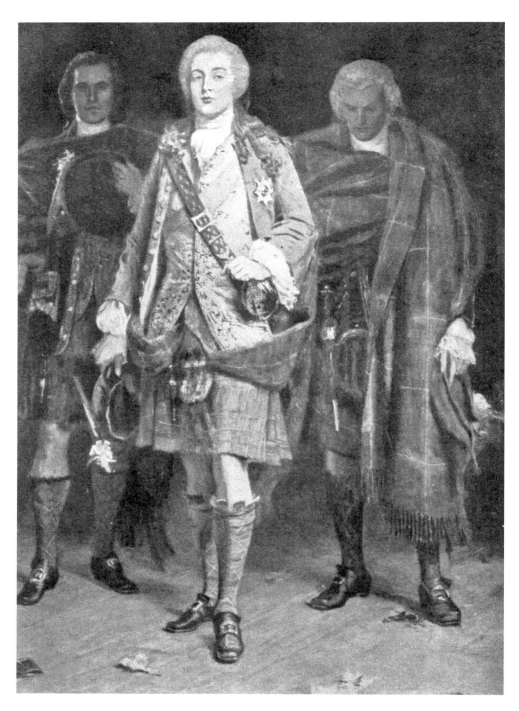

Prince Charles Edward, the 'Young Pretender', had himself crowned as King James VIII but he failed to rally enough support to put this title or his claim to the English throne to a serious test.

The Nor' Loch resulted from the damming in 1440 of the Craig Burn. An artificial lake was created which acted as a deterrent to anyone trying to attack the Old Town from the north. It degenerated into an open sewer and receptacle for rubbish and work began draining it about 1760.

cholera wreaked a terrible toll and crime, deprivation and despair constantly stalked its lands and wynds.

Edinburgh's role as the modern Athens was crowned by the visit of King George IV in 1822. He was dressed very nattily in pink tights under a kilt. The year if not the occasion perhaps marks the heyday of Edinburgh as an epicentre of intellectual achievement in the sciences and arts. The city had huge numbers of surgeons, physicians, philosophers, lawyers and advocates which in turn was reflected in the proliferation of gentlemen's clubs, bookshops and literary and critical magazines that were published in the city. Indeed many famous publishers had their headquarters in the city. Edinburgh further enhanced its reputation as an educational centre with the setting up of such academies as John Watson's, Donaldson's Hospital, Daniel Stewart's and Fettes College, all of which were housed in massively-impressive mansion-like buildings often having a Scottish baronial appearance.

In the second half of the nineteenth century, middle-class suburbs developed around Edinburgh, especially in the Southside. These were composed largely of villas in their

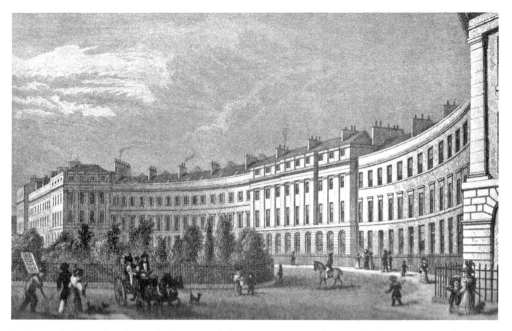

This emphasises the planned elegance of the New Town to the north of the Nor' Loch. It is in stark contrast to the evolved chaos which constituted the Old Town on its restricted site leading down from the Castle.

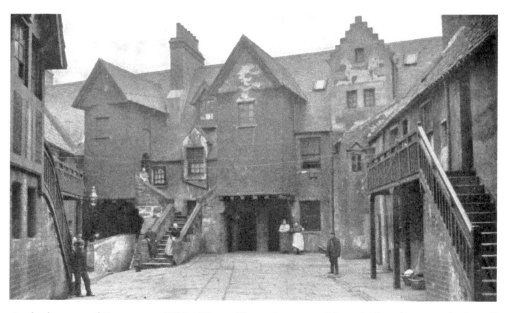

At the bottom of Canongate, White Horse Close gives some idea of what the myriad of small closes and wynds must have looked like before they were demolished or sanitised.

own grounds and of high-class tenements. The areas involved include Grange, Sciennes, Marchmont, Merchiston, Newington and probably the best-known of all, Morningside. From the very start the latter in particular incurred ridicule for its pretentiousness so much so that Robert Louis Stevenson urged Edinburgh's citizens to rise up en masse and burn these places down. They have matured into some of the most attractive and desirable inner-city suburbs to be found anywhere in Britain. Central Edinburgh around the Old Town was a total contrast, festering rookeries of slum housing, despair and criminality, the condition of which was only slowly tackled by the local authority. Even today, there are odd corners of the Old Town, especially around the Cowgate, which still exude at least a hint of the dark horrors of the past. The Old Town area of Edinburgh was thought to be the most densely overcrowded urban district in the whole of Britain.

Parts of Edinburgh are very hilly. In 1888 electric tramways started operating, a form of transport as much associated with Edinburgh as with its very different rival, Glasgow. Trams were well-suited to hilly routes. The last trams ran in 1955 and for many, Princes Street has never been the same since the lines of trams, nose to tail, disappeared. Ironically, trams are on their way back and their reintroduction is causing any amount of frustration and disruption at the end of 2009. The first main line railways had opened in the 1840s, joining Edinburgh to Glasgow and to Berwick-on-Tweed. Edinburgh developed a compact, complex and comprehensive railway system, most of which has been closed. Waverley, however, remains one of the most important hubs on Britain's railway network.

The changes associated with the Industrial Revolution affected Edinburgh less than most other large British cities and it carved out a role for itself as a centre of government and administration, finance, culture, education and research. Edinburgh was and is a city preoccupied with what we would now call the tertiary or service sector. The wealth of significant sections of its population was reflected in the luxury trades to be found in the city such as gold and silver-smithing and also in the quirky industry of wig-making which had much to do with the vast army of lawyers to be found locally. Edinburgh did have manufacturing industry but not of the heavy sort such as textiles and ship-building associated with Glasgow. It had large number of breweries even as late as the 1970s. It possessed distilleries. For a long time it was also a centre of printing and publishing. Mention has already been made of its seaport, Leith. It was a huge advantage to Edinburgh and to lowland Scotland to have such a successful port pointing eastwards, at least from medieval times until the 1960s and 1970s. Leith is still a seaport dealing with ocean-going ships but on a considerably reduced scale from the past.

Since the Second World War, tourism has become a major earner. With devolution, the Scottish Parliament based in Edinburgh gained control over a large amount of the domestic political and economic agenda. Another factor putting Edinburgh on the map

and bringing in large amounts of money is the Festival which was first staged in 1947 and which has now become the largest such event in the world.

However, in the 1950s and 1960s there was a sense that Edinburgh was stagnating. There were proposals that inner-city urban motorways were the solution to the increasing traffic problems and these would have cut a swathe through some of the best parts of the city, much as they were allowed to do with such divisive effect in Glasgow. Prophets of doom inevitably argued, quite fallaciously, that without these roads, business would go elsewhere. New public sector housing on peripheral land replaced much of the worst inner-city housing. These housing schemes, out of sight and largely unknown to tourists and visitors, earned an awesome reputation for social deprivation, drug abuse and Aids. The well-known film *Trainspotting* encapsulated this aspect of the city's past and present. This bleak, black, nihilistic film got its name because many of the smackheads used a derelict railway station in Leith as the place to obtain and take their drugs. Even today, guides to the city suggest that visitors should not venture into parts of Leith on their own. However the City Council was very unhappy about the way that Edinburgh was being portrayed and they discouraged filming on Edinburgh locations. Parts of Glasgow were used instead for many of the film's scenes.

Edinburgh has always been a place of stark contrasts. On the face of it Edinburgh has pulled itself round and presents a vibrant and cosmopolitan front to the world, a style and ambience which 100,000s of visitors annually absorb and appreciate. It is one of the few large cities in Britain, perhaps the only one, whose topography is actually beautiful. It is an extraordinarily diverse place. A capital city, a parliamentary, legal and administrative centre, a focus of education and research, a centre of culture and the arts, it still has important commercial and financial activity; it possesses an abundance of buildings of historical and/or architectural importance. It is a focus of roads, railways and now of air transport. It is still a seaport; it is even a seaside resort with miles of golden sands in the Portobello and Joppa areas. As one wag pointed out, in Arthur's Seat, it possesses the only inner-city mountain in Britain. In recent years many of the city's stone buildings have been cleaned to reveal the lovely creaminess of the Craigleath stone under the grime – we should remember the city's past nickname 'Auld Reekie' but there is much that is still grey and smoke-blackened and which certainly gives parts of the city a dour appearance on a wet afternoon in January.

The authors of this book are unashamed admirers and lovers of Edinburgh and they feel that it is a great privilege to know the city and to be able to write about it. What has been written above is intended to provide a very brief historical background which may be of some interest particularly to those who do not know Edinburgh well.

It would be all too easy to say that one of Edinburgh's remarkable features is its record so far as criminal activity is concerned. In terms of numbers, it is unlikely that crime in Edinburgh has been better or worse than the record of other British cities of roughly comparable size such as Bristol or Nottingham. The innumerable murky legends of

Dr Joseph Bell, believed to have been the inspiration for Arthur Conan Doyle's immortal creation, the detective Sherlock Holmes. He was rather more than a sharp-eyed teacher of medicine with an uncanny gift for deductive reasoning. He was a fine lecturer and a surgeon of considerable standing.

murder, misdemeanour and mayhem, however, have perhaps taken root because of the topography and architecture of the Old Town which was a maze of ill-lit and shadowy wynds, closes and courts. To dive into one of these places off the High Street especially on a foggy night in the autumn is to recall something of the atmosphere of past Edinburgh even in the twenty-first century. It would be fair to say that among the murderous and other criminal activities that have taken place in Edinburgh, there have been some singularly unusual and even outré crimes.

CHAPTER 2

Grisly Murder

In the Scottish tongue a 'baillie' was a senior local councillor. It was an honorary title rather like the English 'alderman' and was conferred in recognition of their supposed contribution to local government. Some baillies were ex-officio magistrates. In 1595 Baillie John Macmorran was murdered in Edinburgh. Murders were by no means uncommon. This murder aroused enormous interest because Macmorran was killed by a schoolboy.

At this time, the boys of the famous and proud old High School of Edinburgh were allowed just 5 days holiday a year and rather strangely, these were all in May. This doesn't seem an overly generous relief from their studies. The boys evidently thought it was not enough because every year they moaned and groaned, culminating in a ritual protest and request for more holiday, which every year was equally ritually turned down. However in 1595 a more bitter feeling suffused the pupils of the High School. They were determined to do something about it.

The scholars of the High School were all the sons of so-called gentlemen, the rich and influential families of Lowland Scotland and of many leading citizens of Edinburgh. The school was in the Blackfriars area close to the Cowgate in what is now called High School Yards. On this particular year the mood had hardened and the boys meant business. They decided to stage a sit-in barring the masters and anyone else from entering. They also armed themselves to the teeth with swords and pistols. Their preparations had even extended to gathering in supplies of food. They were prepared for a siege. They had a doughty leader in William Sinclair.

The Rector of the High School went by the priceless name of Hercules Rollock, a scholar of some renown. On the morning of 15 September, he made his way as usual to open up the school only to find that the boys had got there before him, broken in and erected barricades. He groaned inwardly. What, he asked himself, was happening to today's youth? They seemed to have no respect for their elders and betters. Other schools in the last twenty years had been blighted by similar ridiculous nonsense. Sometimes events had gone so far that the authorities had launched armed assaults on the occupying pupils, retaken the premises and then administered corporal punishment and stiff fines.

Rollock, a man of considerable gravitas, found himself 'barred out'. He gesticulated at and verbally threatened the large numbers of jeering and catcalling heads that occupied all the windows on the street frontage. Appeals to reason fell on deaf ears. He demanded their surrender. They demanded more holidays. Neither side in the confrontation was in the mood for compromise.

Seething with a sense of outrage, Rollock had the commonsense to realise that he was just being made to look ridiculous because not only had the other teachers turned up expecting him to sort the situation out but a sizeable crowd had appeared, as if from nowhere, eager for entertainment and only too happy to see big-wigs like him get their come-uppance. Rollock alerted the authorities who sent a force of city officers commanded by Baillie Macmorran, one of Edinburgh's wealthiest and most respected citizens. Surely the boys would listen to such an eminent local citizen!

Listen they didn't. They scoffed at him and shouted abuse. They threatened worse. It was evident that the ringleader was William Sinclair and he told the Baillie that something nasty might happen if he did not back off. The response of officialdom was to bring up a long beam to use as a battering ram. It didn't work at first but the fact that it was being used at all simply made the boys more angry and abuse, largely verbal, rained down on the attackers. The crowd meanwhile gratefully and gleefully drank in every detail of this unfolding drama; after all, this was before television had been invented. The ram eventually began to do its job and the boys, now fearing the prospect of retribution, began to panic and become more desperate. As the Baillie made another approach to appeal for sense, Sinclair fired his pistol. He hit Macmorran in the middle of the forehead and killed him instantly. Panic-stricken the boys either ran or gave themselves up immediately. Sinclair and six others regarded as the boys' leaders were seized and carried off to the Tolbooth while the authorities decided what to do. Macmorran's family was outraged and demanding justice. They wanted the head of young Sinclair on a plate. Revenge was uppermost in their minds and they were determined that the boy should pay the ultimate price for his action. The father of dear little William, however, was Lord Sinclair, none other than the Chancellor of Caithness. He knew the right people. One person he knew was the King, James VI. He persuaded the King to intercede but James had a difficult job attempting to placate the rich burghers of the city around Baillie Macmorran while not upsetting the Sinclairs and other powerful landed dynasties.

As a result of this all the boys, or aristocratic yobbos, depending on one's point of view, involved in the occupation of the school including the murderer William Sinclair were released as long as their parents removed them from the High School and sent them to another academy elsewhere. However someone had to be punished for having brought the school into disrepute. A scapegoat had to be found. It didn't take them long to find one. Of course the whole regrettable episode was the fault of the teachers. The headmaster, Rollocks, was dismissed after presumably getting a rollicking and all the assistant masters had their salaries cut. Plus ça change!

PHILIP STANSFIELD, THE PATRICIDE

The Edinburgh crowd was not easily shocked. However it was shocked in 1687 when Sir James Stanfield was murdered and they were particularly horrified by the fact that the murderer was his son, a singularly unpleasant individual. Sir James was an Englishman from Yorkshire who had migrated to Scotland after the end of the Civil War. In that war he had served under Cromwell and reached the rank of Colonel. His various businesses, particularly cloth manufacturing, had prospered and he owned property in the Old Town. He lived in a house called New Mills outside Edinburgh in East Lothian. He was a rich, successful businessman and a man widely respected in Edinburgh society. His private life, however, was somewhat dysfunctional.

He did not get on with, and indeed, positively loathed his wife who was a compulsive spendthrift. He also did not get on with his eldest son, Philip, who was a wild, willful, brutal and violent young man. He once threw a missile at a preacher during a boring sermon. The priest was so angry at this rude interruption to his flow that, pointing at Philip, he predicted from the pulpit that the graceless young man would die publicly in front of a far larger crowd than had gathered for worship in the kirk on the day of this particular incident. Philip was unquestionably an out-and-out stinker being constantly embroiled in antisocial or actually criminal activities but his father used his influence time and time again to save him from prison and punishment. This did not lead to any kind of bonding between father and son. Far from it, in fact, the recalcitrant youth simply heaped abuses and curses on his hapless father whose hair grew greyer by the day. The second son, while by no means such a scapegrace, was however, more-or-less permanently drunk. Sir James kept his feelings about his family to himself but privately he must have felt that, in this sphere of life at least, he had failed.

In the end his patience ran out and he disinherited the wastrel Philip. This was in November 1687. Philip swore revenge. One morning shortly afterwards, Sir James was found floating in a stream close to New Mills. Initial impressions were that Sir James had committed suicide by leaping into the river from a nearby cliff. Why he should take such drastic action was by no means clear. The public perception of him was that of a successful businessman and although his son was obviously known for his various misdemeanours, the full extent of the domestic disharmony was not common knowledge.

The death of Sir James had only just been reported when Philip was busy ransacking his father's possessions, removing valuables and he even removed some silver buckles from his father's shoes and put them on his own. He then set about arranging his father's funeral with what people seemed to think was almost indecent haste.

The manager of Sir James's Mills did not believe that his master had committed suicide. This gentleman whose splendid name was Umphray Spurway used his considerable influence to have the body exhumed. All the relatives of Sir James were ordered to be present at the exhumation after which the body was examined for signs of foul

play. Nothing definite was detected but as was custom and practice when there was a suspicious death, the relatives of the deceased were ordered to place the cadaver back in the coffin; this curious requirement was known as 'ordeal by touching'. Various officials stood by, watching.

Philip, as the eldest son, lifted his father's head only for the horrified bystanders to see blood spurting out of Sir James's neck. Understandably, Philip was horrified because he was now seen literally to have blood on his hands. Everyone present thought this was unquestionable proof that Philip, who they had suspected all along, had murdered his father.

Philip Stanfield's trial took place in Edinburgh in February 1688 and he was found guilty very quickly, the trial seemingly a formality. On 22 February he was hanged at the Mercat Cross. His tongue with which he had been heard over the years repeatedly cursing his father was cut out and burned by the scaffold. The right hand with which it was deemed that he had ended his father's life was cut off and fixed to the West Port or gate at Haddington, the capital of East Lothian. His dead body was gibbeted and displayed. Burial was refused, making the gibbeting an aggravated punishment. The mob apparently took it down from the gibbet and threw it into a stinking ditch. The authorities recovered the body, restored it to the gibbet and once again it was removed and mysteriously it disappeared, never to be seen again.

GABRIEL, THE PERVERTED PASTOR

One of the fascinations of Edinburgh is its dual and paradoxical character – of good and evil, culture and crime, opulence, grace and learning with deprivation, dirt and despair. In view of this it is perhaps not surprising that one of the most horrible of murders was committed in 1717 in the area which later became the New Town. This area was on Edinburgh's periphery and a pub called Ambrose's Tavern attracted a slightly bohemian group of intellectuals, men-of-letters and their hangers-on.

One of the pub's regulars was a young man by the name of Gabriel, training to be a pastor of the Church of Scotland, who resided in the house of a well-to-do family where he acted as tutor to the two boys, respectively aged ten and eight. He developed an ardent passion for a pert and toothsome young serving girl who also resided in the house. He was discreet enough not to mention his passion but eventually his action spoke louder than words. He caught sight of her while she was engaged in needlework. He thought she was alone and, suddenly inflamed, he could not stop himself as he walked past and planted a resounding kiss on whichever part of her gorgeous anatomy was closest to hand. Unfortunately the authors cannot be more specific. It was a stroke of ill-luck that one of the boys saw this act, found it enormously amusing and told his brother who promptly related the incident to his mother. She did not think it should be taken too seriously and gave Gabriel a very mild ticking-off.

That should have closed the matter but Gabriel was incensed that the boys had snitched on him. The following Sunday our fledgling man of the cloth, Gabriel, took the two boys to divine service after which, as was also the custom, they went for a walk in the open area where the New Town now stands. It was quiet and no one was about and Gabriel's simmering anger suddenly rose to boiling point. He whipped out a knife, stabbed the totally unsuspecting elder boy in the heart killing him instantly and then smeared some of the boy's blood over his victim and over himself. The younger brother watched this, rooted to the spot with horror and dread. When Gabriel turned to him with murder on his mind, the boy screamed and kept on screaming as he ran for dear life. He gave Gabriel a good run for his money but eventually the tutor caught him and served him in the same way he had done his brother. The screams had attracted other walkers who ran to help the boys and apprehend their assailant, literally caught red-handed. The boys were beyond help and Gabriel was dragged away, scarcely resisting, by a crowd growing by the second as the nature of the awful act that had been committed was passed from mouth to mouth. They soon found a couple of magistrates on their way to worship and they knew the law. As it stood at the time, a murderer apprehended in the act – he was still carrying the murder weapon – did not need to be brought to trial but could be executed with no further ado. The crowd was screaming for retribution, they found a rope and they strung Gabriel up from a handy tree, all within a matter of minutes. Before he was hauled up on the rope, someone had managed to chop his hands off and these gory trophies and the bloodied knife were somehow hung around his neck. Gabriel went up to meet his maker or possibly down in the other direction within minutes of the murders.

THE EVANGELIST WHO WAS NOT ALL HE APPEARED TO BE

William Bennison was something of an evangelical firebrand and religious fundamentalist who enjoyed the respect and admiration of others of a similar kidney. He was a bastion of the Primitive Methodists. Bennison was born in Ireland and in 1838 he married an Irish girl called Mary but left her after a few months and migrated to Scotland. This pillar of righteousness then met a girl called Jean at Paisley and married her. They got on well but perhaps he was having some pangs of conscience because he left wife number two and went back to wife number one in Ireland. It has never been revealed how he explained his prolonged absence – he could hardly have said that he'd popped out to walk the dog – but no sooner had they settled in with each other again than he proposed that they move to Scotland. This they did but Mary's experience of Scotland was short-lived because she died unexpectedly.

History repeated itself. He now went back to Jean. He excused his absence from the matrimonial home by saying that his sister had died and he'd had to look after the arrangements. He must have been extraordinarily plausible but apparently Jean believed

him. He then suggested that the happy couple should have a holiday in Ireland so that she could meet his parents and other relations. She was extremely puzzled when one of these relations turned out to be Bennison's only sister. Most people would have started smelling a rat by now but not apparently Jean when Bennison reassured her that this particular sister of his who had died was a 'sister in the Lord'.

Back in Scotland they moved from the Glasgow area to an address in Stead's Place off Leith Walk. They seem to have settled down and been happy with each other and in 1843 Jean gave birth to a baby girl. It was around this time that Bennison really took up his religious activities with fervour. He attended meetings almost every night, leaving Jean at home contentedly thinking of the good works her husband was performing. In fact he had met another young woman, named Margaret, and he would take her for long walks after the prayer meetings and he even visited her home and met her parents. It is clear that he was lining her up as another Mrs Bennison and the keener he became on her, the cooler he was towards the gullible Jean. He began to hint to people he knew that her health was failing. This was what is known as a 'softening up' process. Jean, incidentally, was perfectly sound in wind and limb.

Bennison had bought some arsenic, not a difficult thing to do in those days: he was plagued with rats, he said. On the evening of 12 April 1850, he made porridge for supper. He laced it with arsenic. The child had already gone to bed and he said that he didn't have much of an appetite but Jean tucked in with relish. Next morning she became violently ill. A doctor was called and gave her medication but she was getting worse by the hour. She died in extreme agony. For his part, Bennison affected grief mixed with joy that she was going to a better place. In reality his joy was, of course, simply that she had gone, never mind where to. Jean's sister, a Mrs Glass, had spent time in the house before Jean died and was aware that he had been making preparations for the funeral with remarkable promptitude – even before she had died! Mrs Glass suspected something, she didn't quite know what, but she did know that she wanted a post mortem. The speed with which he made the arrangements for the funeral attracted the gossip of various neighbours who were becoming suspicious.

Murderers are frequently arrogant people who think that they can outwit the law with ease. Bennison was one such but in his arrogance he was careless, fatally as it was to turn out. He had a bowlful of uneaten porridge. He gave it to a neighbour to give to his dog. The dog died during the night in extreme agony. The neighbours went off to share their thoughts with the Procurator-Fiscal.

It seems that Bennison was by now losing touch with reality. He took himself off to the shop where he had bought the arsenic and reminded the shopkeeper and his wife who was also present of his purchase. They didn't remember him or the specific purchase but asked him what he'd done with the arsenic. Almost casually he said that he had given it to his wife and he would be greatly obliged if they would be kind enough not to mention it to anyone else. Things were happening rather quickly but the two of them were not prepared

to make any such promise. He told them who he was and they knew him by reputation as a religious zealot. They were confused and unsure what to do.

Soon, however, the police arrested Bennison. It began to look extremely bad for him. The small matter of bigamy came out. He denied it. He had only married again in the absolute certainty that his previous wife was dead, he said. No one believed him. As far as the arsenic was concerned, it had been bought to kill rats and the last he saw of it was when he gave it to his wife to distribute around the house, he said. No one believed him. Why didn't he call a doctor as soon as his wife became violently ill? She wouldn't let him, he said. No one believed him.

Bennison appeared in court in July 1850 charged with bigamy and murder and gave a performance of the sort that would have won any number of Oscars had they been invented by that time. He was found guilty and made a speech from the dock in which he thundered that God knew of and would prove his innocence and would find it in his heart to forgive the prosecution for their perjured evidence and the jury for their foolish gullibility. Throughout the hearing he radiated an aura of self-righteous outrage, frequently invoking the name of God when responding to questions. More disconcerting was the gimlet eye he turned on the witnesses and members of the jury. This felt as if it had the power to see right through them to their very inner souls. They did all they could to avoid catching his eye.

Bennison may have given the impression that he was answerable only to a much higher court but his menacing posture and his histrionics did him little good and he was found guilty of bigamy and murder and sentenced to death. The Procurator-Fiscal had decided that there was insufficient evidence to charge him with Jean's murder although everyone thought he had done it.

The public almost always finds titillation in court cases involving murder. The combination of murderer and bigamist with ranting evangelical they found particularly piquant. To tell the truth, most people enjoy seeing a raving hypocrite of his sort being brought down. He thoroughly deserved it.

A FINAL FLING WITH A WHORE

Eugene Marie Chantrelle was a Frenchman who arrived in Edinburgh in 1866 to begin a new life. He was thirty-two years of age, the son of a noted and wealthy family from Nantes and he had excelled as a medical student although he never took up practice. His family had fallen on hard times and he had become something of a political radical which made it advisable for him to leave France, if only temporarily. He was a language teacher providing lessons in French, German, Latin and Greek. Via the USA first and then a spell in England, he gravitated to Edinburgh. He was handsome, elegant and somewhat dandified, talents that he made sure he put to great uses when he found that many women

could not resist him and his charms. In 1867 he seduced one of his pupils, Elizabeth Dyer, no more than a teenager, who had fallen headlong for his Gallic good looks. To their mutual dismay they found that Elizabeth had fallen in another way - she was pregnant. Very much against their better judgment but in order to avoid a lot of dirty linen being washed in public, her parents agreed to the couple marrying.

At first the auguries were good. They moved to elegant quarters at 81A, George Street. Elizabeth was utterly devoted to her new husband and he was earning good money but she quickly became disenchanted, being by no means the first girl to be seduced by a handsome smooth-talker and then to marry in haste and repent at leisure. Chantrelle did not like being trapped in a marriage and he blamed Elizabeth for having become pregnant as if he had had nothing to do with the matter. He took to verbally abusing her in public, to knocking her about and threatening to kill her. Once he waved a loaded pistol at her. On another occasion he threatened to poison her and said that he would use a substance that could not possibly be detected.

He was frequently away from home drinking heavily and consorting with the very worst kind of women in the sinks of depravity which abounded behind the veneer of respectability that was middle-class Edinburgh at the time. Despite his open infidelity, Elizabeth took legal advice only to be told that divorce was out of the question unless she wanted the sordid details to be paraded in all the papers. By 1878 she had three children and she lavished on them the love which she had once extended to her husband.

For a period Chantrelle's treatment of his wife improved somewhat. He had clearly been somewhat chastened after being convicted of having assaulted one of his serving girls while he was drunk. However by now he was in a downward spiral and his reputation was in shreds. His teaching was going to rack and ruin and the income from it began to dry up. By 1877 he was severely in debt. Unknown to Elizabeth he took out an insurance policy on her life for £1,000 if she was to die from any accidental cause. He had carefully checked the exact legal definition of 'accidental death'. Elizabeth somehow managed to find out about this. She was convinced that her husband has made these arrangements for sinister reasons; that he had designs on her life. She was right to be fearful. She mentioned these fears to her mother and told her that she was certain she was going to meet with a fatal accident in the near future.

Sure enough, it wasn't long before Elizabeth fell ill. Chantrelle who seemed beside himself with concern called the doctor and blamed her illness on escaping gas fumes. The state of the Chantrelle's marriage had not escaped the notice of local medical practitioners and an eminent toxicologist, a professor of Medical Jurisprudence no less, dismissed the gas idea and believed that she had been poisoned with narcotics. When Elizabeth died, a post-mortem was held which could find no trace of narcotics in her body but opium was found on the bedclothes and hidden away elsewhere in the house.

Chantrelle was charged with murder and he was tried over four days in May 1878. He was found guilty despite hysterical outbursts and protestations of innocence. He was

hanged in Calton Jail on 31 May 1878 but the night before he had shown that he still had some spirit because he asked the Governor of the Jail for three bottles of champagne and a whore for the night. His request was granted.

PERILS OF POACHING

Late one evening in 1883 two gamekeepers, James Grosset and John Fortune and a rabbit-catcher by the name of John McDiarmid set out, armed only with walking sticks, to look for poachers. They frequently undertook these nocturnal patrols. Poachers were very active at the time. Before daybreak, two of them were dead and two men, Robert Flockhart Vickers and William Innes would die later as a result of the events of that fateful night.

The trial of Vickers and Innes took place at the High Court, Edinburgh, in March 1884. Vickers and Innes were charged with shooting Fortune and McDiarmid, inflicting fatal injuries. They were also charged with assaulting Grosset. They shot him too and inflicted injuries that were not life-threatening. This all took place on the estate of the Earl of Roseberry in Midlothian, just outside Edinburgh to the south.

Grosset told the court that it had been a windy, clear, moonlit night, perfect for poaching but the three of them had seen and heard nothing untoward and decided to give up and go home at about 2.30 in the morning. He himself had just returned to his cottage and was about to open the front door when he heard a distant shot. He immediately rushed to the cottages of Fortune and McDiarmid and the three of them went off in the direction from which the shot was heard. They quickly intercepted two men and called on them to stop whereupon the two men, whom Grosset said he recognised, shot at them. Grosset received superficial wounds and rushed off to get a doctor. The noise of the shots had attracted attention and a number of farm workers rushed to help the injured men.

A couple of hours later and armed with a description of the men, the police visited their various homes. Innes seems to have inflicted injuries on himself because he had a gunshot wound in his jaw which he said he had sustained when his gun went off unexpectedly. That was his excuse for why the gun had been discharged recently. Vickers took more finding but a freshly cleaned gun was unearthed in his cottage. Fortune had no fewer than fifty-two pellets in his body. Innes and Vickers were found guilty of murder by a majority of nine to six, the other three jury members preferring to pass a verdict of not-proven. The men were hanged at Calton Jail at 8.12 in the morning, a black flag at the masthead indicating that the deed was done. Vickers left a widow and 8 weans and Innes a widow and three. It was the first and last time there was a double-hanging at Calton Jail. The men were buried in the precincts as was common practice. All this murder and mayhem occurred just so that a few rabbits could be caught illegally and flogged cheaply around some of Edinburgh's more disreputable pubs.

CHAPTER 3

Some Edinburgh Ghosts

The name of Flodden Field is engraved for ever like some nightmarish incubus on the fabric of Scotland's past. The scale of the defeat can appall even today. King James IV had the support of virtually the whole Scottish nation and an army estimated at anything between 30,000 and 100,000 passed into England. Around 20 to 30,000 probably engaged the English force who they certainly outnumbered. The battle took place on 9 September 1513. The site is close to the A697 from Wooler to Coldstream.

Henry VIII of England was in the bullish early years of his kingship and had decided to invade France, an act of belligerence which immediately prompted James as France's ally to attack England. On the face of it the Scottish army had the great advantages of higher ground, larger numbers and good supply lines but they still managed to snatch defeat from the jaws of a hard-fought victory. The battle was brutal by any standards, both sides indiscriminately slaughtering their opponent's wounded and it is likely that more than 50% of the Scottish force died on the field of battle. They included James himself. Fortunately the English did not choose to follow up the advantage they had gained at Flodden by an invasion of Scottish soil.

The population of Scotland was far less than that of England and it was said that there was scarcely any family in Lowland Scotland that did not lose at least one of its menfolk at Flodden. The psychological damage done to Scotland's collective confidence was enormous and the battle marked the end of a period of peace and prosperity and the beginning of a period of instability and stagnation. 'The Flowers of the Field' is a lament penned around 1750 for the dead of Flodden and its poignant sounds are still heard at Scottish military funerals.

Back in Edinburgh on the night before the battle, the citizenry were preparing for the possibility that English forces might be laying siege in the next few days. At around midnight many people claimed that they saw a band of spectral heralds assembled at the Mercat Cross and they listened in horror as they proceeded to read out a horribly long list of names. It turned out that these names were exactly those of the dead of Flodden Field. No satisfactory explanation has ever been offered of this extraordinary phenomenon.

In the High Street opposite the City Chambers stands the Mercat Cross. It is a nineteenth century replica incorporating part of the fourteenth century original. Important information was pronounced at the cross and executions also took place.

GHOSTS AT THE CASTLE

King Charles II did not take the execution of his father in 1648 lying down as it were. From 1649 to 1660 he devoted himself to one cause – that of trying to regain the thrones of England and Scotland. He arrived in Scotland in 1650 and after suffering various humiliations at the hands of the Covenanters which he put up with for the purposes of political expediency, he managed to get himself crowned King of Scotland at Scone in 1651. Cromwell regarded this as an insult and marched a force into Scotland which occupied Edinburgh.

Cromwell's troops occupied the castle and it was while they were there that a most peculiar event happened for which no satisfactory explanation has ever been put forward. It was an exceptionally dark and cold night when a sentry suddenly heard the rhythmic beating of military drums, the skirl of pipes and the regular tread of marching feet. This frightening noise seemed to be approaching and even though it still seemed to be some distance away, he shouted a challenge. The menacing sound grew nearer. He then fired off

his musket whereupon the noise miraculously stopped. The sound of the shot aroused his officer who was quickly on the scene to find the sentry shaking like an aspen with terror and pouring out a story about an approaching army and this when apparently everything was silent and in good order. The officer was angry and ordered that the soldier be taken away under guard to await a disciplinary hearing. A second sentry took his post and a few minutes later heard what he also described as an approaching army accompanied by the sound of the pipes. The second sentry fired a shot into the air and the noise stopped. His officer, now seething with wrath, had to listen while the severely shaken sentry described what he had heard. Muttering darkly about the man having dreams while sleeping on duty, he ordered sentry number two to be detained. He then called for a volunteer to complete the sentry's watch. There is an old expression in the army that a volunteer is the man who doesn't understand the question. The fact that no volunteers came forward suggests that this particular group of soldiers understood the question only too well. In the absence of a volunteer, the officer detailed a third man to take over as sentry. He may well have been cold, he may well have been fearful, but he spared the officer further disturbance. We cannot comment on the fate of the first two sentries but no explanation has ever been proffered for these bizarre events that freezing night in 1651 at Edinburgh Castle.

Anyone who looks at Edinburgh Castle can be excused for thinking that its motley collection of buildings houses a thousand secrets and mysteries. Just one of those mysteries occurred in 1689. In that year Lord Balcarres was residing in the castle as a prisoner on account of his activities in support of the Jacobite cause. The conditions of his captivity were clearly not too onerous because he was lying in a four-poster bed during the day with the curtains drawn to keep out the draughts. He lay there simply doing nothing except keeping warm when to his great surprise and without the rest of the body making any noise, a head appeared through a gap in the curtains. The head belonged to his great friend John Graham of Claverhouse, immortalized as 'Bonnie Dundee'. Balcarres was pleased to see his chum but wondered what on earth he was doing there. Their eyes met for only a second or two before the head was withdrawn. There was a curiously questioning look in Claverhouse's eyes. Nothing was said. Not a word was exchanged, it was total silence. Somewhat reluctantly because of the cold, Balcarres stirred himself and drew back the curtains. Claverhouse had simply vanished. Not one to let himself get cold without good reason, Balcarres climbed back into bed but he was a deeply puzzled man. He was even more puzzled when, a few days later, he received the sad news that Claverhouse had been killed on the field of battle at Killiecrankie, ironically just as he was about to achieve his greatest victory. The puzzle is that the appearance of Claverhouse's head through the curtains in the room occupied by Balcarres had occurred precisely at the moment of his death so many miles away. Apparently the ghost of Claverhouse has made sporadic appearances within the castle precincts ever since.

SKULLDUGGERY AT OLD CRAIG HOUSE

In the suburbs of south Edinburgh is Easter Craiglockhart Hill (519 feet). Nestling close by is Old Craig House. This is a crow-stepped and harled building dating back in parts to 1565. It is one of the oldest houses in Edinburgh and is supposedly haunted by the ghost of the 'Green Lady'. This by itself is worth comment since most of the ladies who are said to haunt places are normally described as being white or grey or black. Anyway the Green Lady is supposed to be the ghost of Betty Pattindale, a young woman of some beauty who resided in the house around the turn of the eighteenth century. Her lover was a dashing young officer who fought under the Duke of Marlborough and who, curiously, she only knew by the name of 'Captain Courage'. They had pledged their eternal love and they wished to marry. However he told her that he could not do so until such time as his father died and left him what he expected to be a large legacy. In the meanwhile he was penniless and had no option but to go off and rejoin his unit.

Betty's parents were determined that she should make a financially and socially advantageous marriage and they were sure that they had found the right man in Sir Thomas Elphinstone. Sweeping aside whatever objections Betty may have voiced, not least that Sir Thomas was forty years her senior, they arranged for the wedding to take place. Shortly after the wedding, Sir Thomas announced to his young bride that his son who was a soldier was returning from the wars and that a great reception would be arranged by way of celebration. Some of our more alert readers, assuming we have any, may have realised where this story is going. The young soldier, Colonel Elphinstone, who was her step-son of course, proved to be none other than the beloved one who she still fondly thought of as 'Captain Courage'. To say that both Betty and the young Colonel were a little put out by this turn of events would be something of an understatement. In fact, they were totally nonplussed. Young Elphinstone was completely distraught and broken-hearted and he vowed to go away for ever. Had there then been a French Foreign Legion to join in order to forget, he would certainly have rushed off to enlist in it. However, very pragmatically, he proposed to his step-mother that before he returned to his regiment, they should share a quick cuddle – just for old time's sake of course. Well, the cuddle became increasingly impassioned and the couple understandably got carried away. In walked her husband and his dad who were, of course, one and the same man. Sir Thomas, found his wife and her step-son *in flagrante delecto*. Suffused with rage, he took out a dagger and rather melodramatically stabbed Betty right through the heart. Young Elphinstone disappeared – forget the 'Captain Courage' tag.

Later the same day, Sir Thomas returned to the chamber in which the murder had taken place to gaze ruefully down on the bloodied body of his lovely young wife. The sight was too much for him. He collapsed and died, falling over the body as he did so. The two of them were buried in the same grave and it was immediately after the interment that the haunting started. The two of them reappeared as ghosts with that of Betty shrilly

demanding that she be removed from such close proximity to the husband who had murdered her. The ghost of Betty always appeared dressed in green hence the logical nickname. Anyway, with these two apparitions ranting and raving at each other, life in Old Craig House became perfectly intolerable and eventually the owners decided that the Green Lady's wishes should be observed and so Betty's remains were exhumed and placed in her own grave set some little distance from that of Sir Thomas. Having got what she wanted, Betty must have stopped the hauntings although on occasions later residents and visitors have claimed to have seen a spectral young lady in ancient green fashions flitting around the house. We must assume that Sir Thomas sleeps on.

HORROR AT QUEENSBURY HOUSE

At the foot of the Canongate stands Queensbury House. Even by Edinburgh standards, this building has had a troubled history. It is a tall, gloomy building which has been dogged by misfortune. When it was being put up in the 1680s, it hit the news because the then owner, Charles Maitland, Earl of Lauderdale, experienced labour problems with the construction workers who did not consider the wages he offered acceptable. Maitland brought in workers from outside Edinburgh who were prepared to do the job for lower wages. Blacklegs are never popular except with the employers. The situation was only sorted out after a pitched battle in which the blacklegs were vastly outnumbered and routed by the massed ranks of local workers. Their spirit broken, the outsiders limped away from the field of battle, nursing cracked heads, blackened eyes and missing teeth as they went.

No sooner was the house completed than it was bought by the first Duke of Queensbury. He was under official disapproval because of his strident opposition to the pro-Catholic policies of James II. The Duke was therefore greatly relieved when James was overthrown and the Protestant William of Orange took the English throne. Happy to get out of Edinburgh, he set off for his country seat at Drumlanrig but he quickly fell ill, being convinced it was something to do with his new surroundings. He decided to head back to Queensbury House and Edinburgh where plenty of doctors were on hand. He had never much liked the house – he thought it was a gloomy pile – but it was where he resided for the rest of his life. He added to the gloom of the place by spending his last few years there as a miserable recluse.

In 1700 his daughter had somehow managed to set fire to herself. In her panic she ran through the house screaming with terror like a human torch with her nightdress ablaze. She lost her eyesight and received such severe burns that she died shortly afterwards. A few years later, the second Duke of Queensbury was busy with the negotiations that led to the Act of Union, eventually passed in 1707. He had inherited Queensbury House. His role in these discussions was widely known and earned him the hatred of the Edinburgh

citizenry, the vast majority of whom were hostile to anything that strengthened links with the 'auld enemy'. From time to time, there were riots over the issue and crowds assembled outside the house making their views on the Duke's activities very clear. It was not helpful from the Duke's point of view that he had a lunatic son, James Douglas, Earl of Drumlanrig, who murdered a young boy who worked in the kitchens in the house. Now murder was by no means uncommon in the Canongate but this particular murder excited singular fascination mixed with revulsion because the Earl dismembered, roasted and ate as much of the scullion as he could stomach. Its bodily parts having been largely recycled, the soul of the kitchen boy lived on, inhabiting those parts of the building which, because of its duties, it was most familiar with. The house was converted to flats in the eighteenth century. In 1803 it became a barracks and has subsequently been a refuge for the destitute and a hospital.

Headless in The Meadows

The Meadows is a much-loved area of open space to the south of the Old Town. It once contained a number of scattered buildings including one which went by the name of 'Wright's Houses'. In 1792 one of the residents was a retired senior army officer. In the course of his duties around what went on to be the far-flung British Empire, he had taken on a servant, a native of Africa, who was known as 'Black Tom'. This man had accompanied his master back home. It had long been prestigious in wealthy circles to employ servants of African origin but there were few enough of them in Edinburgh at this time to raise eyebrows whenever they were seen in public. What Black Tom thought of being exiled to Britain let alone to Edinburgh we will never know. We do know that he complained to his boss that his nights were being made unbearable by a ghost which frequently visited him in his sleeping quarters. He was being scared witless by the apparition of a headless woman bearing a child in her arms. He was not taken seriously. In the 1890s, Wrights Houses were being demolished when an old stone floor was ripped up and under the slabs was found a space containing the headless skeleton of a woman clutching an equally skeletal infant close to her.

Canongate and Corstophine

People walking in St Mary's Street in the Canongate have claimed sightings of a ghost of a young woman, with a look of surprise and terror on her face and with blood on her clothes. It is thought that this is the spirit of a young woman who, in 1916, was stabbed to death for no apparent reason other than that she was in the wrong place at the wrong time. Her attacker, who was never brought to justice, just disappeared.

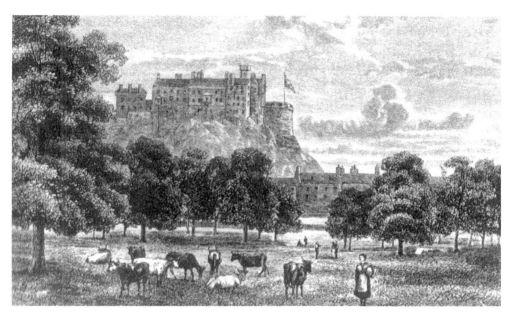

The Meadows constitutes one of the oldest of Britain's public parks and is a much-loved 'lung' close to the city centre. In the 1960s there were serious proposals to build an urban motorway through The Meadows.

The present-day desirable suburb of Costorphine is not, at first sight, the kind of place that appears likely to be haunted, least of all by the figure of a young woman dressed in white and running around brandishing a sword dripping with blood. This apparition is supposed to be the ghost of Christine Nimmo, an attractive young woman married to a rich, older but very boring man with various business interests in the city. To add some much-needed spice to her life, she took a lover who, like her, was already married. Although they enjoyed many steamy sex sessions together, she was aware that he was also a drunkard and a loud-mouthed braggart when in his cups. She was enraged when she learned that he had been regaling his drinking companions with some very intimate details of their sexual trysts. These included particularly lurid details of the notably unusual and demanding preferences and proclivities she engaged in between the sheets. The rest of the story is predictable. She arranged to meet him. Understandably, she expressed the anger and disgust she felt at him making these revelations to the toss-pots with whom he drank. He just sneered and so Christine, suddenly losing her temper, stabbed him to death. She fled, was caught, escaped and was then caught again. In due course she was executed, having chosen to be dressed all in white for the occasion. Is it her spirit that cannot lie at rest in Corstophine?

Edinburgh is a city of ghosts. Here we have only been able to offer a sample.

CHAPTER 4

Deacon William Brodie — A Real Life Jekyll and Hyde

Edinburgh is a city much of whose history is redolent of mystery, intrigue and skullduggery. One of the city's most famous rogues went by the name of 'Deacon' William Brodie. Born into a comfortably-off, well-established and very respectable local family in 1741, young Brodie followed his father into the family business of cabinet-making. Brodie inherited over £10,000 when his father died in 1782. This was a tidy sum in those days and it should have meant that Brodie was well set up for life. He lived in the Lawnmarket in the Old Town.

By day, William Brodie was to all appearances a successful businessman, a skilled cabinet-maker and head of a firm which gained many contracts to make furniture for the well-heeled of Edinburgh. As well as apparently being of impeccable rectitude, Brodie was widely respected. For a time he served with distinction on the Town Council. The informal title 'Deacon' by which he was known did not mean that he was a man of the cloth but referred to the fact that he was in effect the senior figure in the local guild of cabinet-makers and carpenters. Unfortunately he was addicted to gambling and it was through the activities he undertook in order to feed this habit that he gained immortality. Wearing two faces as it were, he has become the archetype of a schizoid rotter and also the prototype for an enduring fictional character.

He was the leader of a gang of four. His criminal syndicate consisted of himself and George Smith, Andrew Ainslie and Humphrey Moore who also went by the name of John Brown. Smith was an Englishman, a higgler or tinker and also a locksmith who had come to Edinburgh to see whether he could make a fresh start for his somewhat nefarious business activities. He was addicted to gambling and he frequented 'Clark's', a rather louche drinking and gambling establishment in Fleshmarket Close which runs between the High Street and the Cowgate in the heart of the Old Town. This area was a common resort of criminals and the four men got to know each other through gambling and drinking.

Brodie kept fighting cocks and lost large amounts of money while backing them and engaging in other games of chance. His gambling addiction meant that his money worries were more or less permanent. He recouped some of these losses by cheating with loaded

dice but did so cleverly enough not to be found out. He was a sociable man who enjoyed convivial company but he was careful not to allow his judgment to be affected by the drinking he did. He was popular with those he knew in this underbelly of Edinburgh society and he adroitly managed to maintain an almost total divide between what he did there and his more public persona as one of the city's most upright and stalwart citizens.

Brodie was nothing if not a busy man because in addition to his legitimate business as a cabinet maker and his gambling and criminal activities, he ran three households. He shared his home with his sister's family but also a mistress who bore him two girls and a boy and lived in Cant's Close. Another mistress lived in Liberton Wynd. She gave him two sons. Since these places, now gone, were literally just around the corner from the Lawnmarket, it is remarkable that Brodie was able to operate in this way for many years without either of his women realising that the other existed. Clearly however, enjoying the favours of two mistresses and a bevvy of children was not only physically demanding but involved considerable financial outgoings. To give him his due, he did not shirk these responsibilities but they meant that he was under constant and considerable pressure to use any means he could in order to raise funds. He often had to visit the premises of clients where he and his employees undertook work. Some of these clients were well-off and he soon realised that he could use the work he was doing as an excuse for casing their joints. At a later date he would revisit these places with his accomplices in the capacity of head of a gang of burglars.

It was the habit of the Edinburgh shopkeepers of the time to hang the keys to their premises on a nail at the back of the shop during trading hours. Brodie would go round to one of these shopkeepers either for a business discussion or just for a blether and when an opportunity presented itself, he would make an impression of the key in a lump of putty that he took round with him precisely for this purpose. The rest was easy. Many bold burglaries took place masterminded by Brodie on the premises of Edinburgh people who he knew well and who in turn knew and respected him. However honest 'Deacon Brodie' was above suspicion. Occasionally he broke into places alone. On several occasions he was seen and identified but no action was taken because the witnesses simply could not believe that it was the upright Brodie that they had seen.

The full extent of the criminal activities of Brodie and his gang will never be known. It was evident however that they were thieves in a big way, specialising in breaking into the premises of jewellers although they varied this from time to time with surreptitious nocturnal visits to silk merchants and tobacco merchants. They had an arrangement whereby suitable goods they had stolen were taken south to a receiver apparently near Chesterfield of all places. They had certainly carried out a number of successful and profitable robberies in the town, the equivalent of hundreds of thousands of pounds by today's prices. One of the boldest and to the authors the most piquant of the gang's crimes was the illicit removal of the silver mace of Edinburgh University that was kept in its library. This must surely have been difficult to sell on. Perhaps they already had a buyer lined up.

After many successes the gang, of which Brodie was the undisputed leader, decided to 'do the big one' – to break into and rob the General Excise Office for Scotland. In this building was housed much of the collected tax and revenue from the whole country. This should have been deposited securely in a bank but they knew that in practice large quantities of money were often kept in a very casual way in the cellar of the office itself. They hoped to make enough from this one job that they would all be able to retire in comfort and put the criminal life behind them, a by no means uncommon aspiration in the underworld.

By nefarious means Brodie managed to obtain an impression of the key. He also fixed the layout of the room in his mind and members of the gang staked out the building for some time to see what the night-watchman's procedure was. Eventually, when they were sure that they knew the ropes, the gang set out for the General Excise Office in Chessel's Court, armed to the teeth. They broke in without any difficulty on an exceptionally freezing and pitch-black night. Ainslie was placed on guard while the other three went off to find the large quantity of cash that they felt certain was there waiting for them. While they were making their way through the building, one of the officials came back to the office, having forgotten to take some personal item home. Extraordinarily, this man seems to have been completely unfazed to find doors open and lights on and actually to see Brodie walking down the passage. After all, it was Brodie. Everyone knew what a pillar of the community he was. He must have assumed that Brodie was there in some official capacity but anyway the man went to his room, found what he was looking for and after exchanging a few pleasantries with the Deacon, he left the building. As soon as he had gone, they set to again searching for the money. It was soon obvious that something was wrong. Ransacking everything with an increasing sense of desperation, their efforts were crowned when they managed to find just a paltry £16 in a cashier's draw. They weren't to know that there was £600 in a secret drawer underneath.

They met up next day to divide up the booty, feeling resentful that they had garnered so little in spite of the risks that had been taken. The others made it quite clear that they blamed Brodie for the frugal results if their efforts and the attendant risks they had undergone. By now, Brown had other things on his mind. He knew that there was reward of £150 for any person offering information that would lead to the conviction of the person or persons responsible for a robbery from a shop in the Old Town the previous year. This robbery had been carried out by the gang of which he was part. Brown was tempted to go for the reward. He became more tempted when he learned that any crimes previously carried out by the informer would receive the King's pardon. He had plenty to be taken into consideration. He was on the run from a sentence of transportation imposed in England.

With this in mind, he turned himself in and fingered Smith as well but not Brodie. When the latter found out that two of the gang were now locked up in the Tolbooth, he decided it was time to make himself scarce. He fled to London and then to the Continent,

thinking to return to Edinburgh when the fuss had died down. He sailed in a small vessel that regularly plied between Edinburgh and London, travelling by sea being the quickest and safest route between the two capitals at that time. Carrying out various items of business in London, Brodie then embarked on a return vessel making an arrangement for the boat to put in at the Flemish port of Flushing and drop him off there before heading back to Edinburgh. He got out of London because he had found that the authorities had spread their net and that there was hue and cry for him there. It is probable that he had by now resolved to try to get to North America after putting various affairs in order back in Edinburgh.

By this time Brodie had assumed a disguise, almost certainly not a very good one and the false name of 'Dixon'. He now committed a foolish error of judgment. This was very much out of character because he owed the success of his double life to a careful evaluation of the situations in which he found himself. He entrusted two of his fellow-passengers, a Mr Geddes and his wife, with three packages to be delivered in Edinburgh. When Geddes arrived in Leith, one of the first things he decided to do was to catch up with the news. The main story related to one Deacon Brodie and his criminal activities. The Geddes quickly realised that 'Dixon' and Deacon Brodie were one and the same. He opened the letters only to have his suspicions confirmed and, scenting the possibility of a reward, he then went to the Sheriff.

Brodie was traced to Amsterdam where he had fled prior to taking a boat from there to South Carolina. However he was arrested, extradited, brought back to Edinburgh and lodged in the Tolbooth. The three other gang members were also incarcerated there. Brown had been officially pardoned for all his past crimes, one of which was murder, to enable him to appear as a witness for the prosecution. He was still in the Tolbooth for his own safety. Then Ainslie decided to turn King's evidence as well. This left Brodie and Smith to carry the can. If he was worried, Brodie did not show it. He laughed and joked with all in earshot.

That Brodie was a showman there is no doubt. Somehow or other, he managed to get the authorities to agree that he and his co-defendant should be carried to the court in chairs. So the crowd which was following events with enormous interest was treated to the bizarre sight of Brodie and Smith lying back in their chairs while accompanied by a large squad of soldiers with fixed bayonets. Brodie dressed up and looked every inch the respectable town burgess.

It would be wrong to say that the outcome was a foregone conclusion but the evidence was strong. Not the least of Brodie's problems was that his house had been searched and a number of pistols and skeleton keys had been found – hardly the stock-in-trade of the respectable cabinet-maker! The jury found both men guilty and the court decreed that they should hang for their crimes. The death sentence was to be carried out on 1 October 1788. Time had run out for Brodie and he was hanged on top of a single-storey building which projected from the Tolbooth, before a huge crowd. He went to his death with great

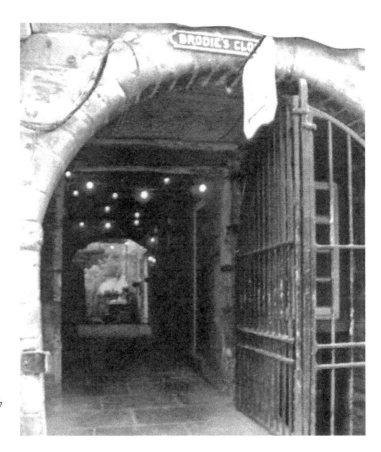

This piece of Edinburgh real estate belonged to Deacon Brodie's father.

courage and dignity. He was dressed immaculately and he bowed graciously to those he could identify in the crowd.

It took three attempts to extinguish Brodie's life. Rumours circulated that an arrangement had been made with the hangman to try to ensure that Brodie did not actually die and certainly his body was driven away in a cart at great speed so that an attempt could be made to resuscitate it. Such efforts were fruitless. The fact is that he was dead. He was buried in the kirkyard near George Square and Buccleuch Place. Brodie's Close which can be seen in the Lawnmarket was a property belonging to Brodie's father.

The name of 'Deacon' Brodie lives on because it is widely believed that his life provided an inspiration for one of the most striking of Robert Louis Stevenson's literary characters, that of Dr Jekyll and Mr Hyde. Stevenson was fascinated by what he thought of as the duality of human nature and he decided to develop this idea and share it with his readers by making the interplay of good and evil the main theme for a short novel. He believed that good and evil exist in all humans and that those who do not recognise the existence of their own evil alter ego, unwittingly project the evil in themselves onto others.

No.17, Heriot Row in the New Town was once the home of Robert Louis Stevenson (1850-94). He wrote adventure stories, romances and thrillers, the best-known of which was probably The Strange Case of Dr Jekyll and Mr Hyde, *published in 1886.*

In 'The Strange Case of Dr Jekyll and Mr Hyde', Dr Jekyll is a virtuous man who brews up a medicinal potion which transforms him into Mr Hyde who encapsulates all the evil aspects of Jekyll. Stevenson was a habitual drug-user and was under the influence of cocaine during the three to six days that he took to work flat-out completing the first draft of the story. When the completed work was published in 1886, it was an immediate success on both sides of the Atlantic and the book or its underlying theme have been made the subject of innumerable other novels as well as plays and films. Everyone knows what kind of a person a 'Jekyll and Hyde' is.

CHAPTER 5

Some Edinburgh Punishments

Halifax, in what was once the West Riding of Yorkshire, was a centre of the cloth industry as early as the thirteenth century and by the fifteenth century was the most important wool-manufacturing town in Yorkshire in terms of output. So important was the cloth industry to the economy of the town that the local magistrates assumed draconian powers to deal with those found guilty of stealing cloth, a lucrative crime for those who could get away with it. Part of the process of manufacture involved stretching the cloth out on a frame called a tenter and this was done out in areas of open ground where there was plenty of space. The expression 'on tenterhooks' is a reference to this. Because this process was usually done well away from buildings, it provided ample temptation to the criminal fraternity, the cloth being extremely valuable. The magistrates enjoyed exercising these powers and as is the nature of such things, seamlessly extended them to punish other types of offender. They had a particularly formidable weapon in their fight against crime. This was a type of guillotine which went under the name of the 'Halifax Maiden' or 'Halifax Gibbet'.

This devilish mechanism stood on an elevated platform and consisted of two wooden uprights fifteen feet in height connected by a beam at the top. The inner surfaces of the uprights had grooves in which ran a heavy square timber block to the bottom of which was attached a sharp iron blade. The block containing the blade was held in place at the top of the frame by a wooden pin. A long rope passing over a pulley was attached to this pin and when it was tugged, the pin was withdrawn causing the block and the blade to drop with lightning speed.

Many people in their fantasies have acted as the executioners of people they particularly disliked but at Halifax, fantasy became reality. As might be expected, huge crowds were guaranteed to turn out to watch miscreants having their lives extinguished by this simple but ingenious killing machine. The authorities in Halifax decided to dispense with the services of an executioner. Instead, when the victim was kneeling down between the uprights, neck at the ready, they threw the rope into the crowd and as many people as could, got hold of it and gave it a tug. This may seem an anarchic idea but it did mean that no one person could be identified as having dealt the fatal blow, as it were. It is said

that the Halifax Maiden severed its victim's head with such force that it often flew some distance away, occasionally landing in the crowd. There is a story, possibly true, that a stranger to Halifax was riding her horse along a street near the execution site when she was suddenly confounded to find herself staring into the eyes of a bloodied and newly detached head that had flown through the air and landed in her saddlebag.

The Halifax Maiden was, in its way, a most impressive machine. One who saw it in action and was struck by how such a device might come in useful sometime was James Douglas, Earl of Morton. He became Regent of Scotland in 1572 but it was a few years earlier that he had been passing through Halifax. He took some measurements, made a few sketches and, having stuffed the drawings down his bulbous breeches, then rode off happily northwards. When he got back to Scotland, he put his carpenters to work building a slightly modified version of the device that had so impressed him at Halifax. Its blade was made of iron edged with steel and was similarly released by means of a rope and pulley.

THE SCOTTISH MAIDEN

A subtle refinement for what quickly became known as the 'Scottish Maiden' was a bar which held the victim's neck in place and prevented him from withdrawing his head at the last minute, a design fault which had occasionally led to a few messy problems when the Halifax prototype was in use. In Scotland, the services of the public executioner were employed, much to the disappointment of the many Edinburgh devotees of public executions who were in favour of doing things the more democratic Halifax way. In other words, they wanted to have a go themselves!

This device did indeed come in useful during the Earl of Morton's Regency. He was a complete duffer so far as economic affairs were concerned but right on the ball when waging war on truculent rebels and others who defied his authority. The Scottish Maiden stood in the High Street near the City Cross. It did the business for at least one hundred victims. With a certain rough justice, the man who had been so enamoured of this death-dealing apparatus found himself testing its efficiency. It was not found wanting when he was executed for having been involved in the death of Darnley, husband of Mary, Queen of Scots, in 1567. Another victim of this evil machine was the Earl of Argyll who made the mistake of supporting the hopeless uprising in 1685 which was intended to put James, Duke of Monmouth, on the English throne. The Scottish Maiden was dismantled in 1710. It had given good value for money. It now resides in the collection of the National Museums of Scotland. Doubtless there are some who would like to see it brought back into service.

PERSECUTING WITCHES

The practice of witchcraft became a criminal offence in Scotland in 1563. A few women condemned as witches were burnt at the stake but it was only with the accession to the throne of James VI in 1566 that the hunting down and persecution of witches began in earnest. There is a record that David Seaton who was the deputy bailiff of Tranent, a small town about ten miles from Edinburgh, decided that a young girl in his employ was probably a witch. She was seized, tortured with the thumbscrews, and then had ropes tied very tightly round her head. At this stage despite having suffered appalling pain, she would not co-operate but when Seaton found what was claimed to be the Devil's Mark on her throat, her resolve evaporated and she admitted having dealings with the Devil.

Maybe her motivation was that if she was going to go down, she might as well take some more people with her. She claimed that she was one of a group who, in addition, had concocted a frightful plot against the king. Among those she named were a respectable midwife, Agnes Sampson; John Fian who was a schoolteacher; and two women considered to be staunch and upright citizens of Edinburgh – Euphemia Maclean and Barbara Napier.

Agnes was cross-questioned at Holyrood by none other than King James himself who seems to have extracted great pleasure from personally terrifying the abject woman. She was charged with no fewer than fifty-three offences, all of which she denied, after which her entire body hair was shaved off and every part of her body poked and prodded until the Devil's Mark was found. This piece of irrefutable evidence then acted as an excuse for more drastic measures. She was chained to the wall of her cell by means of a 'witch's bridle'. This consisted of an iron frame with four prongs that were forced into her mouth, two against her tongue and the others against her cheeks. She was deprived of sleep and also had ropes tightly bound around her head. This treatment soon provoked a confession.

As so often happened in these situations, what she said was a farrago of absolute nonsense. She described how in late 1589 she and several other women and six men had sailed in a fleet of sieves from Leith to North Berwick. When they got there they cast a spell for the raising of a tempest which would sink the ship in which James was returning across the North Sea with his bride, Anne of Denmark. Barbara and Euphemia told similar stories. Fian was described as the man who transmitted the instructions from the Devil. He and Sampson were strangled and then burnt at the stake. This was regarded as preferable to the penalty inflicted on Euphemia who was simply burnt alive. Barbara 'pleaded her belly'. The authorities examined her and, satisfied that she was pregnant, kept her in prison for some months and then released her. The history of Scotland was blighted over the next century or more by the systematic and hysterical persecution of witches.

PRESSING MATTERS AND OTHERS

Peine forte et dure was a torture usually reserved for those who refused to submit to questioning or would not enter a plea. The authorities disliked them as timewasters so to speed things up even the merest mention of *peine forte et dure* was usually enough to ensure that the victim sang like a bird. The prisoner was spread-eagled on his back on the floor, restrained so that he could not move any of his limbs. A large, flat surface such as a door was placed over his torso and heavy weights put on it. A couple of such weights usually achieved the desired result as the prisoner agreed to co-operate. If he still refused, the threat of further weights usually produced the required response. Sometimes to make the experience even worse, a sharp stone might be placed under the prisoner's back. The excruciating agony of 'pressing', for this is how the procedure was normally described, would be intensified the longer the prisoner held out. Sufficient weights would crush the ribs and the fractured bones would penetrate the internal organs causing a singularly painful and unpleasant death. A few doughty prisoners resisted for a long time. In 1726 an English prisoner called Barnworth held out for more than two hours before submitting. He had 400 pounds on his chest. After the Union the practice of pressing spread from England to Scotland and it was used on a number of suspected witches in Edinburgh and elsewhere. Ideas associated with the Enlightenment led to a more humane penal policy and in 1772 pressing was abolished.

The depths of human ingenuity are plumbed when it comes to devising methods of inflicting pain on other humans. The ostensible purpose of torture is, of course, to extract information and therefore those who inflict it rarely want their victim to die before he has revealed all he knows. An ideal torture instrument is that which only has to be mentioned as a threat or shown to the victim for his resolve to evaporate in an instant. One such was the Boot, employed in Scotland in the sixteenth and seventeenth centuries. Although this came in a number of styles, the principle was the same. The victim had his legs below the knee placed into a device looking like a boot and which had holes through which wedges were hammered crushing the flesh and breaking the bones. One hapless victim of the Boot was John Fiennes, accused of witchcraft. His legs were so badly crushed that the marrow was forced out of them. Later he spent an unhappy time on the rack and what was left of him was later strangled and then burnt at the stake at Edinburgh Castle.

Thomas Papley from the Orkneys was charged in 1596 with taking part in black magic rituals. He was unlucky enough to be used as a guinea pig for the Caspicaws, an upgraded version of the Boot where screws rather than wedges were used and the boot-like instrument could be heated until red hot just in case the victim was inclined to think that his inquisitors had gone soft. Not many women spent time in the boot but one who did was Margaret Wood, tortured in Edinburgh in 1631.

In Edinburgh in 1652, two Englishmen whose crime had been to drink the King's health, received thirty-nine strokes of the whip on their bare shoulders and backs, had

their ears nailed to the gallows and then their tongues pulled out to their full extent whereupon their tormentors somehow tied their respective tongues between two sticks for nearly half an hour. In 1650 a man who had born false witness had his tongue pierced with a red hot iron.

Something of a Scottish speciality was the thumbscrews sometimes known as 'Pilliewinks' or 'Pilliewinkies'. These were a kind of metal nutcracker which exerted crushing pressure on the victim's fingernails. They were employed to extract information from William Carstares who was implicated in the Rye House Plot to assassinate Charles II and his younger brother the Duke of York, the future King James II, in 1683. Carstares was tortured for around an hour in the thumbscrews which were screwed so tightly that they could not be removed until the smith who made them managed to do so with the aid of some of his specialist tools. It was worth it. The authorities got much of the information they wanted without the expenditure of too much time.

Back in 1437 King James I had been assassinated and it was decided to make an example of the Earl of Athol, ringleader of the gang who plotted to kill him. He was taken to the usual spot, the City Cross in Edinburgh's High Street, where he had his flesh torn

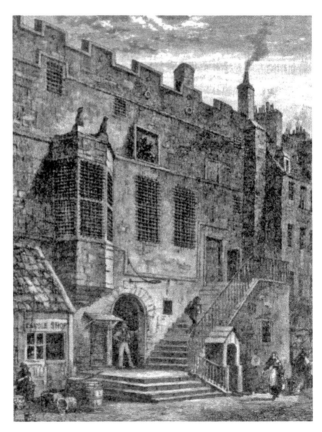

This is 'The Heart of Midlothian' which, like other public buildings in the area, served various purposes over the years. This was variously a town hall, a customs office and a prison. It was in the latter role that it was most notorious.

Close to the High Kirk of St Giles, picked out in cobbles is the Heart of Midlothian which marks the site of the Tolbooth, built in 1561 and demolished in 1817. The building underwent many uses but most famously acted as a particularly feared prison and place of execution.

with red hot pincers and he was the crowned in a mock ceremony as 'King of Traitors'. The crown was of red hot metal. In 1798 Scotland abolished torture – officially.

In medieval and early modern Scotland, prisons were not used as places where convicted prisoners served custodial sentences. As in England, they were mostly used to house those awaiting trial or execution or perhaps some other punishment such as banishment. The Tolbooth in Edinburgh was an example. This was located near St Giles and was demolished in 1817. This is easily confused with the Canongate Tolbooth which was built in 1591 and closed as a prison in 1840, now being used as 'The People's Story' Museum. Leith had a Tolbooth from 1565 to 1824. Other places of confinement were 'Bridewells' and 'Houses of Correction' were minor offenders such as mendicants were put to work. The conditions in such places were indescribable.

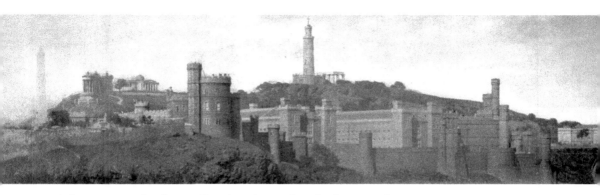

A distant view of Calton Hill with Calton Jail in the foreground.

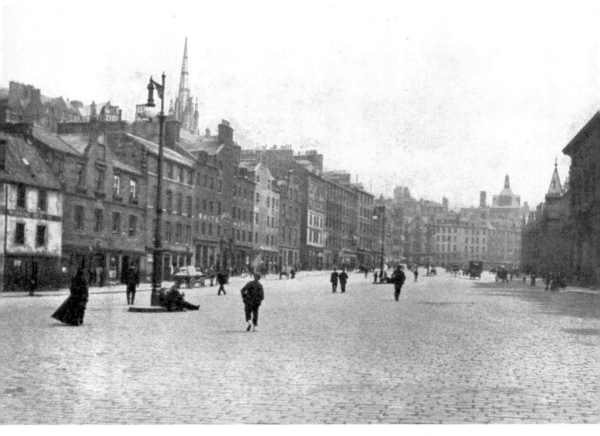

The Grassmarket is a focal point in the Old Town and was formerly a market where the products of Edinburgh's rural hinterland were bought and sold. By the 1970s it was notorious as the meeting place of the city's most depraved and seedy elements. It has now been gentrified but manages to retain at least some degree of character. Traditionally this was one of Edinburgh's major places of execution. Many hundreds kicked out in their death agonies at this spot – doubtless some of them innocent of the crimes of which they had been accused.

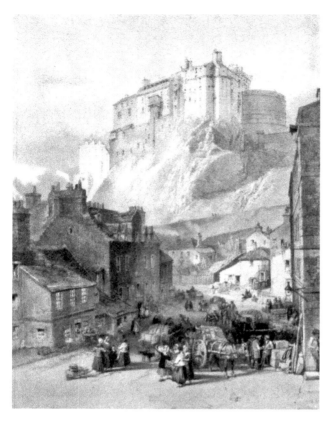

A view of Edinburgh Castle from the Old Town.

A well-established principle of punishment was that the convicted offender should pay financial compensation to his victim. Elaborate scales were drawn up putting a monetary value on such things as the loss of use of a finger or a complete hand as the result of an assault. These scales varied with the class of the offender and the injured party. It was, for example, regarded as a far more heinous crime deserving of greater compensation for a poor person to inflict an injury on one of higher birth. The value of the compensation fell dramatically in cases where one of high standing injured another of lowly status.

Physical punishments were employed for certain crimes and it was not uncommon, for example, for a thief caught red-handed to have his 'luggs' (ears) cut off or to be whipped and then hanged. A fine, perhaps a branding or a whipping might be imposed for a fairly trivial offence where it was not thought that the offender was a threat to society and needed more serious punishment. Once such punishment had been meted out, the offender was free to go. Those found guilty of what were regarded as the most serious offences such as witchcraft or 'unnatural crimes' were likely to be burnt at the stake.

The Church had its own courts who inflicted severe physical punishments for such offences as blasphemy, sabbath-breaking, swearing and adultery. Offences regarded as

One of several hostelries in the Grassmarket, this name is an example of gallows humour.

comparatively trivial might involve a fine or perhaps a spell in the pillory, or both. Even as late as 1692 the Church authorities hanged a student in Edinburgh, one Thomas Aikenhead, for having publicly described theology rather eloquently but unwisely as 'a rhapsody of ill-invented nonsense'.

The Old Tolbooth near St Giles which had been known as 'The Heart of Midlothian' was replaced by a large new purpose-built prison known as Calton Gaol at Calton Hill where St Andrew's House now stands. A high, bleak-looking wall of the fortress-like Gaol has survived and visitors arriving at the Waverley Station from the Berwick direction who do not know the city often look up and think they are looking at Edinburgh Castle. Prisoners from right across Scotland were housed within its gaunt precincts but it in turn was replaced in 1925 by what is now HMP Saughton, at the west end of Gorgie Road.

The locations most associated with executions in Edinburgh are the Grassmarket, Castlehill, the Old Tolbooth, Gallowlee in Leith Walk and at the Mercat Cross. Sometimes executions took place where the crime had been committed and the last time this happened

was in January 1815 when two men convicted of highway robbery were executed at the junction of Braid Road and Comiston Terrace in Morningside. A plaque in the pavement marks the spot. The last public execution in Edinburgh was carried out in 1864 at the top of Liberton Wynd in Parliament Square.

CHAPTER 6

Death, Destruction and Disaster in the Old Town

Ever-present in the Old Town in Edinburgh was the danger of fire. Many of its ancient higgledy-piggledy buildings had thatched roofs and were timber-framed. Heating came from open hearth fires, there were thousands of multi-occupied cramped and overcrowded buildings housing downtrodden folk whose only solace was in drink; candles provided lighting. The old Town was a tinder box waiting to ignite. Frequently it did so.

The most serious conflagration occurred in 1824 and it devastated a large part of the Old Town. Dozens of fires, many minor, others serious, occurred every year in the district but none of them could compare with the extent of the destruction caused by this fire which blazed for three days and laid waste to virtually the whole of the south side of the High Street between Parliament Square and the Tron Kirk. If any good came out of this event, it was that it led directly to the formation of the world's first municipal fire service.

The fire was discovered about 10 o'clock in the evening in a 7-storey tenement and it quickly spread to adjacent buildings. Fire-fighters were soon on the scene but their efforts were hampered by the difficulty of getting access into and through the labyrinthine mass of dark closes and wynds. Their efforts managed to prevent the fire's eastwards spread but could do nothing to prevent its westwards advance and when a slight change of wind occurred, the fire hungrily spread southwards and soon much of the Cowgate area was consumed. The wind eventually dropped and the feeling was that the fire could be left to burn itself out. However sparks must have got through a broken window and then set fire to the inside of the Tron Kirk. It had a spire of wood lined with lead which was soon blazing merrily and sending streams of molten lead down onto the streets below. Somehow, despite this spire collapsing, heroic efforts saved much of the building.

There was once again a feeling that the fire had run its course when, exactly 24 hours after the first outbreak, another fire was discovered in an 11-storey tenement overlooking the Cowgate. This building was simply too tall for what passed as the fire service of the time and the fire went on to devastate a huge area just to the south of the High Street. At one time St Giles was threatened. In Scottish dialect the name given to the tall tenements in the Old Town was 'Lands' and many, from 4 to 11 storeys in height were reduced to

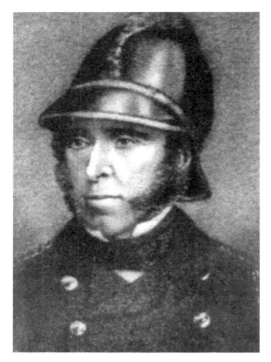

James Braidwood, the first Master of Fire Engines. Many of his early efforts at extinguishing fires were hampered by huge numbers of 'rubber-neckers'.

nothing more than shells and had to be demolished as unsafe. Several deaths – possibly as many as thirteen – resulted, a small number given the extent of the fires.

The damage caused was estimated even then at more than £200,000. The fire convinced the town fathers that they should establish a municipal fire service because the fire brigades attached to the various insurance companies would usually only deal with the buildings that they had been paid to protect. The few volunteer fire services were, as we would say these days, underfunded, but also inefficient and ineffective. The result was the creation of the world's first fire service paid for largely out of municipal funds.

The first commander of Edinburgh's fire brigade was James Braidwood. He was only twenty-four years of age and was given the grand title of 'Master of Fire Engines' although it is unclear what his qualifications were for the post. He went on to become the first head of the London Fire Engine Establishment and became enormously respected but he died in 1861 supervising operations in an enormous fire in warehouses on the south side of the Thames in the Southwark area. A plaque to Braidwood can be seen outside the Fire Brigade headquarters in Lauriston Place.

Fires were not the only hazard to buildings in the Old Town – sometimes they simply collapsed. At the entrance to Paisley Close in the High Street can be seen the effigy of a boy and an inscription, 'Heave awa' chaps, I'm no dead yet.' These words were allegedly spoken by a young lad called Joseph McIver unearthed from rubble and wreckage

when on 24 November 1861, the properties numbering 99 to 107 High Street collapsed without warning in the early hours of the morning, killing thirty-five people. The building concerned was an ancient building once lived in by well-to-do citizens but by this time was what we would now call a multi-occupied dwelling, about eighty-five feet or five storeys high. Some idea of the overcrowded nature of the Old Town can be gauged from the fact that eighty-three families lived in these dwellings.

The efforts of the rescuers were hampered by the fact that the buildings had more or less collapsed inwardly and so there was a huge amount of debris from which they had to try to extract bodies and survivors. Many of the dead showed no sign of injury and had simply died of suffocation. One or two had literally died in their beds – when found they were still in them. The rescuers' efforts were hampered by the awareness that the surrounding buildings might also be unstable.

Investigations suggested that large parts of the beams that constituted the timber framework of the buildings which collapsed were riddled with dry rot. As with the awful fire of 1824, however, some good came out of the disaster. The appalling structural decay of many of the buildings in the Old Town was highlighted and steps were taken to survey and where appropriate to demolish or repair some of the worst of them. Within months Edinburgh appointed its first Medical Officer of Health as recognition that the overcrowded Old Town had a host of public health issues which needed to be addressed seriously.

To return to our young lad trapped under the rubble and other debris. He was buried so deeply that only his foot was visible. He was eventually extracted with only the slightest of injuries and he immediately called for a drink. Considering how close he had been to death or perhaps awful injury, his courage and even his *sang froid* were remarkable.

The well-known carved relief commemorating the fortitude of the young man who had been trapped in the tenement collapse but refused to give up hope.

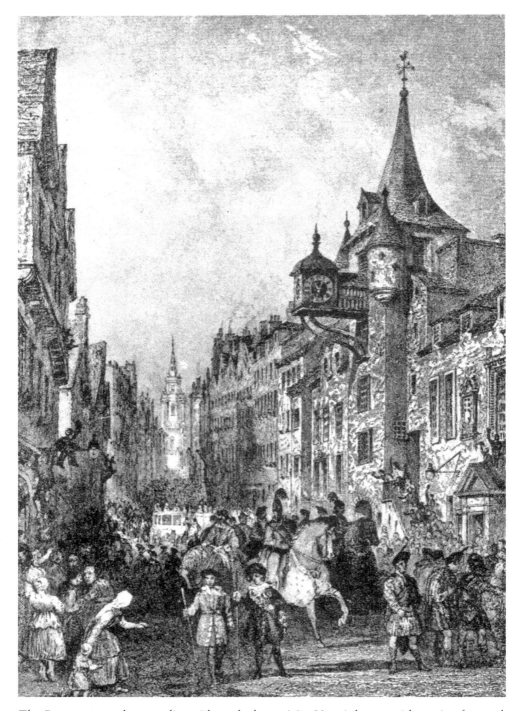

The Canongate can be seen alive with workaday activity. Now it heaves with tourists for much of the year.

This explains why he was immortalised with his effigy in the High Street. The little effigy stands at the entrance to Paisley Close.

The Old Town in the eighteenth and nineteenth centuries was a cosmopolitan, grossly overcrowded quarter where people lived not only cheek-by-jowl with their human neighbours but with many semi-feral animals including pigs and dogs and also a host of small workshops and business premises. The work conducted in these places often added to the many other environmental hazards. One day in October 1867 in Chessel's Court at 240 Canongate, a firework-maker called Hammond was busily completing an order for rockets when some sparks set fire to the exceedingly flammable materials all around the workshop and the resulting fire spread with terrifying rapidity. Two kegs of gunpowder in the workshop exploded with such force that the windows in an apartment upstairs blew out and shards of glass embedded themselves in the stonework of buildings across the street. The building itself became an inferno. Heart-rending cries came from those trapped in the upper stories. Five people died and the death toll would have been far worse had it not been for the skills of fire-fighters and the heroism of local residents. Yet again it took the occurrence of a disaster for action to be taken. Crowded residential districts such as Canongate were not the place for workshops and small factories, especially when they handled such potentially dangerous materials as those used in the making of fireworks. The local authorities took steps to inspect such premises and when necessary to force them to relocate.

LYNCH LAW AND THE PORTEOUS RIOTS

Many visitors to Edinburgh make their way to historic Greyfriars Kirkyard. Within its walls lie buried many of Edinburgh's eminent citizens and not a few out-and-out villains. One largely neglected slab is that which covers the mortal remains of John Porteous. The inscription is not easy to decipher but it reads: "John Porteous a Captain of the Edinburgh City Guard murdered 7 September, 1736. All Passion Spent 1973." For most of the last 250 years the only indicator of the last resting place of Porteous was a simple wooden post, perhaps indicative of the widespread disdain in which the man was held.

Edinburgh or at least Leith being a seaport, witnessed some smuggling, usually fairly small-scale. Sometimes smugglers got away with their crimes partly because they enjoyed considerable popularity among local people who bought smuggled goods tax-free and at cheap prices. No one liked Customs Officers and few would do anything to help them, let alone inform on smugglers. However on occasions the Customs people did manage to apprehend an offender and have them prosecuted and convicted. In 1736 they seized Andrew Wilson and George Robertson and confiscated a valuable cache of contraband they had smuggled. The two men were extremely annoyed at this loss of potential income. They were determined to get their own back and shortly after the seizure and with the help of some associates, they robbed a Customs Officer of £200. Wilson and

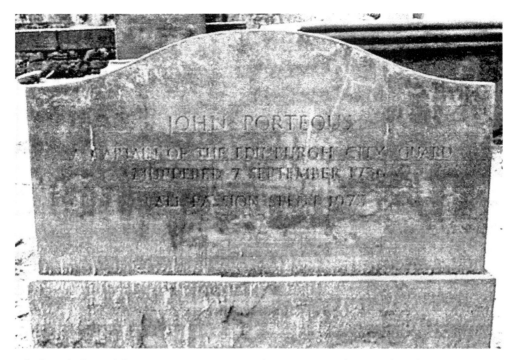

The burial place of the egregious Porteous can be seen in Greyfriars Kirkyard.

Robertson carried out this robbery so brazenly that the authorities were soon able to arrest the men. They were condemned to death and lodged in the Edinburgh Tolbooth part of which acted as a cell for those awaiting execution.

It was the practice at the time to take condemned prisoners to divine service in St Giles Church on the last Sunday before the day set for their execution. They were accompanied by four guards and had already decided that if they saw a chance of escaping, they would take it – after all, they had nothing to lose. At a prearranged signal, Wilson attacked the guards who he caught totally unawares. One of them he bit and the other two he punched and pummelled while Robertson evaded the grasp of the other, leapt over the pews and disappeared out of the door. The congregation watched all this with something approaching admiration and word quickly got around about Wilson's unselfish action in giving Robertson the chance to escape.

The Edinburgh crowd, or mob depending on how it was seen, was notorious for its volatility. It had a rough-and-ready sense of justice. Smugglers were popular and by now Wilson was now a local hero, the man of the moment. There was a widespread feeling in the city that he did not deserve to be judicially hanged. The authorities were concerned that the time and place set aside for the public execution of Wilson might be made the occasion of a rescue attempt.

It was decided to take no chances. On 14 April, the day set aside for the execution, the Trained Bands were called out – these could be described as volunteer special constables. The City Guards were on hand with loaded muskets. Regular soldiers garrisoned in the city were put on stand-by. This show of force may have prevented any rescue attempt but only aggravated the crowd already particularly incensed by the fact that Captain Porteous was commanding the Guard contingent. He had been an army officer and was widely hated locally for his violent temper and inflexible attitude towards offenders, even of the petty kind. Porteous himself was in a foul mood. He was extremely irked that Robertson had apparently got clean away. He was also seething with rage that the Trained Bands and the soldiers were on hand. He took this as a slight on his City Guard who in his opinion could do the job of guarding Wilson perfectly well. It was the unfortunate condemned man who bore the brunt of his anger. Porteous decided that Wilson should be manacled for his journey from the Tolbooth to the place of execution in the Grassmarket. The manacles were too small but Porteous somehow got them in place, taking no notice of Wilson's piteous screams of pain. These screams were readily audible as Wilson was being marched along and absolutely incensed the crowds who lined the route. An ugly mood was developing.

A vast crowd had gathered in the Grassmarket but given the show of force, they did not try to rescue Wilson and the sentence was carried out. Reports now become confusing. It was said that a number of small boys stoned the hangman as he cut down Wilson's inert body. Such demonstrations of distaste for the hangman and his job were by no means uncommon but nerves were on edge and the tension almost tangible. The City Guards were wholeheartedly loathed by the citizens and were particularly jittery. When stones started flying their way, their response was to began firing above the heads of and then into the densely-packed crowds. Porteous should have read the Riot Act giving the crowd the opportunity to disperse but he failed to do so. Witnesses said that he was the first to start firing. This was never proved but after these shots had been fired he ordered his force to retreat which they did amidst a hail of catcalls, screams of rage and pain and more missiles. Further shots were fired and soon around sixteen people who had been in the crowd lay either dead or badly wounded.

To his chagrin, Porteous found himself hauled up before the magistrates and charged with murder. The court found him guilty and he was sentenced to be executed on 8 September. Porteous appealed to King George II in London. He was out of the country but his Queen who rejoiced in the name of Caroline Wilhelmina of Ansbach had little knowledge of or interest in what was going on in a distant and what she thought of as a barbaric corner of the realm. Unaware of the political nuances of her action, she ordered a reprieve, pending a likely full pardon when her husband returned.

When the news leaked out, the citizens were outraged. Not only was the hated Porteous going to get away with murder but this heinous miscarriage of justice was being dictated to them by the equally loathed authorities far away in London. This

therefore became an issue having nationalist ramifications. Quickly an accord developed that Porteous must die whatever the authorities decreed. The Lord Provost was warned that an attempt was going to be made to seize Porteous but, for whatever reasons, he took no action. Porteous himself, seemingly oblivious to the nemesis being planned for him, sat in the Tolbooth and organised a booze-up with his few friends as a celebration of his imminent release.

What happened next is wrapped in some mystery but quite clearly a determined and well thought-out coordinated strategy was quickly put into action. This involved sealing the city gates or ports and then a crowd marched, accompanied by the ominous sound of a drummer, from the Grassmarket to the Tolbooth. Overwhelmed by sheer numbers, the City Guard was powerless to intervene as the crowd approached the Tolbooth. The magistrates, scared out of their wits by the angry mood, appealed for calm and for the crowd to be reasonable and to return to their homes. They had no force with which to back themselves up and so they stood by powerless when the mob began to attack the Tolbooth. The outer door was thick and strong and staunchly resisted assaults with sledge-hammers and crowbars until some bright spark suggested setting fire to it. Flammable material was quickly gathered up, including tar-barrels and there was soon a merry blaze. The gaoler was sensible enough to surrender his keys and the crowd broke in quickly recognising the hated Porteous. He by now was in his cups but the fact that he was found cowering in a chimney suggests that he was sober enough to get the drift of the crowd's intentions towards him.

He was seized and half-dragged, half-carried in procession from the Tolbooth to the Grassmarket, a burlesque on the official route he would have taken to a judicial hanging. The crowd was so huge that it seemed as if the entire citizenry must have been out on the streets. However, this was clearly not so because every window along the route was crowded with further onlookers. Despite the excitement all were remarkably quiet and restrained until the Grassmarket was reached. A shop in the West Bow was broken into so that a rope could be obtained but it was somehow symbolic of the occasion that a guinea was left behind on the counter to pay for it. There was no permanent gallows so a pole protruding from a shop front was appropriated for the purpose and Porteous was hanged from this. He took a long time to die, kicking out convulsively in his death agonies. This seemed to assuage the anger of the crowd who, having seen what they regarded as justice done, quietly started to melt away, curiously leaving behind them the weapons they had seized from the hapless City Guard. The inert body of Porteous was cut down and eventually buried in the kirkyard at Greyfriars.

The city authorities were now all at sixes and sevens realising that they were answerable to London for the monumentally incompetent way in which they had handled things. Their knee-jerk reaction was to offer the substantial reward of £200 for information that would lead to the conviction of anyone involved in the lynching. Only one person came forward to claim the reward. He was a half-wit who had been drunk and incapable while

these events had been taking place and little credence was given to his evidence. Large numbers of people were arrested and questioned and then released for lack of evidence.

When news of the lynching reached London, and they say that bad news travels fast, the authorities there initially decided to deal with their Scottish counterparts in an extremely heavy-handed fashion. It was proposed to disqualify the Lord Provost from holding office and to imprison him for a year, to disband the City Guard, demolish the Nether Port and compensate the widow of Porteous for her loss to the tune of £2,000 funded courtesy of the Edinburgh taxpayers. In the event, only this latter requirement was proceeded with although Mrs Porteous seems to have been happy to have been fobbed off with £1,500. Perhaps she was as little enamoured of her husband as everyone else seems to have been.

A feature of the lynching was the high level of co-ordination and efficiency that seems to have underpinned the day's activities. Various theories have been advanced that it was the work of what later and in very different circumstances elsewhere came to be known as 'outside agitators', in this case possibly associates of Wilson and Robertson from Fife. The truth will never be known but the city fathers of Edinburgh seemed to be very keen as far as possible to erase the memory of this sordid episode and it was not until 1973 that some kind of acknowledgement was made of the last resting place of the egregious Porteous.

The shop in the West Bow, actually at No. 89, continued to sell ropes right into the 1960s and became something of a place of pilgrimage for those eager to follow up the places associated with the Porteous riots. The ground floor is still used as retail premises.

It is unlikely that anyone in the Edinburgh mob would have said, "let's lynch Porteous." 'Lynch' is an eponymous word and is derived either from the name of William Lynch (1742-1820) or Charles Lynch (1736-96). They were both Virginians associated with the meting out of rough justice to outlaws in the turbulent days of the young American nation during and after the revolution. It took some time for the word 'lynch' to come into use of this side of the Atlantic.

CHAPTER 7

Murder Galore

The Warriston Estate used to stand along the north bank of the Water of Leith to the north of the New Town of Edinburgh. The name of the estate is recalled in the present-day Warriston Crescent and Warriston Road. The mansion, Warriston House, has long since been demolished.

In 1600, John Kincaid, the Laird of Warriston, lived in the house with his beautiful young wife, Jean Livingstone, known by courtesy as 'Lady Warriston'. He was considerably older than she and it was an open secret that their marriage was not turning out to be a happy one. Few doubted that he loved her but the age difference and her desire to spend time with people of her own age made him jealous and resentful. It was thought that he hit her from time to time and that, although she was not unfaithful, she had married him for his money and did not reciprocate his feelings of love. It seems that she was miserable enough to decide eventually to rid herself of her husband.

Lady Warriston employed a female companion called Janet Murdo who acted as a confidante and in whom she confided that she wished for her husband to meet with a premature end. Janet in turn was friendly with Robert Weir, a stable-lad on the Warriston Estate. She thought that he might be able to help in what was delicately described as 'this matter'. Even if he wasn't, she thought that he might know someone prepared to do the deed, whatever it was. If all else failed, she might even consider doing it herself.

When she apprised Weir that she might have a small job for him and that it would be a good little earner, he became very interested. In due course he met Lady Warriston to find out and discuss exactly what she had in mind. It was agreed that he would be admitted to the cellars of the house there to await the onset of darkness.

It was about two in the morning when Lady Warriston made her way through the darkened, silent house to fetch Weir from the cellar. They moved very quietly but made just enough noise to wake up Kincaid as they entered his bed-chamber. He sat up in bed, the lady of the house made herself scarce and Weir, in a frenzy, flew at Kincaid, kicking him so hard on the side of the head that he fell out of bed and onto the floor. In a trice Weir was on him with his hands around his throat and strangling the life out of him. It was quickly over.

Weir fled. The next morning the officers of the law turned up at the house. It is not clear why they should have done so on that particular day – perhaps it was just 'routine enquiries' but it was soon evident that something was amiss in Warriston House. The widow led the men up the stairs to the chamber containing the body of her dead husband. Even an absolute tyro would have recognised the signs of a violent struggle. They immediately arrested Lady Warriston, Janet Murdo and two other female servants who lived on the premises. They were placed in the Tolbooth.

The four women appeared before the magistrates on 3 July 1604. Unfortunately the trial records do not exist but it seems that Lady Warriston did not actually plead 'not guilty'. Janet and one of the other two women servants were convicted and the second servant appears to have turned King's Evidence. It is believed that this lucky break for the authorities occurred after she had been threatened with 'The Boot' a fiendish artifact which the authorities often found was of considerable use in helping them with their enquiries. (It is mentioned in the section on punishments). Lady Warriston tried to make it clear that the two serving women were not involved and she told all and sundry that she had sinned and should be punished. She got what she wanted – decapitated by the Scottish Maiden (described in the same chapter). The execution was carried out at three in the morning. Her influential friends greatly resented the shame she had brought on the family and brought pressure to bear that the sentence should be carried out at a time when relatively few people would be about. She died at the Girth Cross at the foot of the Canongate. Despite the ungodly hour, a large and ghoulish crowd turned out. Although watching a wretch die on the Maiden did not make for great viewing because it was over so quickly, the size of the crowd probably had something to do with the fact that they enjoyed seeing someone of supposedly higher birth get their comeuppance. The other two prisoners were strangled and then burnt at the stake at the same hour but away up the Canongate, High Street and Lawnmarket at Castlehill. Their death agonies would have provided better entertainment for the spectators.

Robert Weir managed to evade the authorities for almost four years but when he appeared in court in June 1604 the case was little more than a formality. A condign fate awaited the evil Weir. He was sentenced to be executed by being broken on the wheel at the Cross whereupon his dead remains, still attached to the wheel, were to be taken and put on display in the Warriston area near the scene of his crime. Weir's gory remnants would remain in place as a salutary warning for those contemplating the murder of anyone of noble birth. Only when all the flesh had been picked off the bones by the fowls of the air would burial take place.

HOGMANAY 1811

The approach of Hogmanay always tended to elicit mixed feelings in the bosoms of those in Edinburgh responsible for the maintenance of law and order. Yes, it was good to see

people enjoying themselves welcoming in the New Year, nobody begrudged them that. The problem was that certain elements among the revellers chose the occasion to make trouble and things could turn ugly. They frequently did.

One such year was 1811. Midnight had not struck before there were reports of gangs of armed youths roaming the streets picking on people at random and assaulting and robbing them. These were large gangs, estimated at as many as fifty and they had left behind them a trail of broken heads and other injuries sustained by innocent people who just happened to be in the wrong place at the wrong time. One gang turned on a police officer patrolling the High Street. He was seriously injured, was rushed to hospital and died five days later. A reward of 200 hundred guineas was offered to anyone who provided information that led to the arrest and conviction of any of those involved. A few days later a man from Leith died of injuries received on the night of Hogmanay and another 100 guineas were added to the reward.

The public expected results and criticised the police for being slow in getting them. Arrests were eventually made and a John Skelton appeared in court on 2 March 1812. He was found guilty of both robbery and violence and sentenced to death. Just over a fortnight later, four men appeared facing between them a total of eleven charges. One escaped from custody but the others, all aged between 16 and 18, were sentenced to be hanged in the High Street, close to where they had assaulted the police officer. The punishment was aggravated for one of them whose body was to be dissected and anatomised. Four more youths were rounded up and upon being convicted of robbery on Hogmanay night, were sentenced to transportation.

The youths had to wait a month between sentencing and execution. On 22 April a temporary scaffold was erected and vast crowds turned out, attracted by the prospect of seeing three felons swing – all for the price of one. Gallows crowds were always volatile. Good humoured banter could quickly turn into a violent and destructive riot and so the authorities were taking no chances. Large numbers of police turned out as did the Militia and contingents of Dragoons and even a body of sharpshooters. There was no violence that day except the State violence wreaking revenge on the woebegone youths, all of whose swagger had long since evaporated to be replaced by last-minute piteous appeals for clemency and then, as they swung in mid-air, the final indignity of evacuating their bowels. It was what the crowd had come to see.

PRITCHARD THE POISONER

The relationship that patients have with their doctors is one uniquely based on trust and on their competence, skill, scrupulous professionalism and personal detachment. Their everyday work gives doctors access to a range of substances used for the treatment of their patients. Some of these are poisons. Many doctors have been murderers. In fact it

sometimes seems as if a disproportionately large number of doctors have been murderers. We are sure that this is not actually the case but it may be that those doctors who do have murderous intentions enjoy greater opportunity to put them into practice because it is relatively easy for them to gain the confidence of their victims and to be alone with them. Their ready access to poisons gives them the means to commit murder. It is certainly true that few doctors have shot their victims, thrown them in front of trains or bludgeoned them to death.

In 1865 there occurred a classic example of a Victorian Poisoning Case. Every element of a Victorian melodrama was present in the case of Dr Edward William Pritchard. Here we have an unwanted spouse slowly being poisoned to death, illicit extra-marital affairs conducted by the murderer, revelations in court about the real person behind the mask of respectability and justice done in the final condign reckoning for the miscreant on the gallows.

Pritchard was a graduate of King's College Hospital, London, who gained his qualifications with the Royal College of Surgeons in 1846. In 1850 he married Mary Jane Taylor, went into general practice in Yorkshire and in 1859 bought a practice in Glasgow. He was ambitious and not only wanted to rise in his chosen career but also wished to become a prominent public figure. He did indeed become prominent but not in the way he would have intended.

He first came to the attention of the authorities when, in May 1863, a fire partly destroyed the attic of his house. The charred, dead body of the family maid was found in the burnt-out room. At first sight, it seemed that she must have been reading in bed by the light of a candle and then fallen asleep whereupon the candle somehow ignited the bed clothes. Obviously the girl's death had to be investigated but what started out as more-or-less routine enquiries soon took on a more sinister aspect. A number of questions needed answering. Was there a link between the girl's death and the fact that, although unmarried, she was pregnant? Was it simply coincidence that the fire had started when Pritchard was the only other person in the house – his wife being away at her parents in Edinburgh? Why was the bedroom door locked – from the outside?

The insurance company was convinced that the fire had been started deliberately and they refused to pay for the damage. For their part, the police surmised that Pritchard was the father of the unborn child, that the pregnancy would have been an embarrassment to him in all sorts of ways and that he therefore murdered the girl. He had the motive, the means and the opportunity. Perhaps he had brought her a nightcap laced with a powerful sedative, watched her fall asleep, set fire to the bed clothes and then left the room, locking the door as he went, just in case the girl came round and tried to escape from the flames.

Proving it was another matter but there was no smoke without fire and the ensuing scandal did Pritchard a lot of harm. News got around, his practice fell away and he got into financial difficulties. To escape gossiping neighbours, he moved the family across Glasgow

to a new address partly paid for by his wife's parents. Before long he was philandering again. As before, it was with a young live-in servant. She was only fifteen and he first impregnated her and then performed an abortion. It proved impossible to keep the matter secret. Mrs Pritchard had just about learnt to live with her husband's first proven infidelity but a second was too much to bear and she gave him a piece of her mind. No sooner had she done this than in October 1864 she was taken ill – with what Pritchard diagnosed as a nasty chill. She suffered chronic vomiting and diarrhoea and it was decided that she should go back home to her parents in Edinburgh so that they could look after her.

She made a quick recovery. However no sooner had she returned to Glasgow than she became very poorly again. This time she also suffered intense stomach cramps. By the beginning of February 1865 Mrs Pritchard was sufficiently ill for her mother to come over from Edinburgh to nurse her. By this time she was beginning to sense that foul play was involved and this turned to certainty when she, her daughter and the cook all became violently ill after eating tapioca pudding. We have no way of finding out whether she confronted her son-in-law with her suspicions but on 24 February she was suddenly struck down and was carried to a bed in a coma.

A doctor was called – he was a crony of Pritchard and he reported that she gave the impression that she was under the influence of opium or some other potent narcotic. This may have been stating the blindingly obvious because the old woman had been suffering for years with neuralgia for which she took a concoction called 'Battley's Sedative Solution'. She had become happily addicted to this preparation because of its high morphine content but it was later discovered that the patent medicine that she had been taking while staying at Glasgow contained two other substances which were not part of Battley's recipe. These were aconite and antimony salts. Old Mrs Taylor died. Soon afterwards, Mrs Pritchard became progressively more poorly and on 17 March, she died. What seems to have finished her off was an egg flip lovingly prepared by her husband because he said it would perk her up. It obviously hadn't. A maid in the kitchen who had tried a sip or two out of curiosity became violently ill although she recovered.

Pritchard appeared to be beside himself with grief. Conveniently he signed the death certificate himself giving the cause of death as gastric fever. He seemed totally inconsolable and rather melodramatically insisted that just before his wife was interred, her coffin should be opened so that he could kiss her luscious lips one last time. His performance while doing this brought tears to the eyes of the assembled mourners.

Soon after Mrs Pritchard died, the Procurator-Fiscal received an anonymous letter the contents of which gave him no option but to have the bodies of Mary Pritchard and her mother exhumed. The internal organs of both the women revealed large quantities of antimony and it was clear that the younger woman had absorbed this systematically over several months.

Pritchard was arraigned for murder and found guilty on two charges. He was sentenced to hang at Glasgow on 28 July 1865. It seems that during the trial, Pritchard began to

lose the plot because he made three separate and at least partly contradictory confessions. As he was hanged, he achieved that which he had always craved – fame. Perhaps we should say infamy. No fewer than 100,000 people turned out to watch him die – one of the largest gallows crowds in Scottish criminal history – such was the interest which his activities had generated. His execution was the last public hanging in Glasgow.

This case continues to have puzzling features. What exactly was Pritchard's motive in murdering his wife? He stood to make no financial gain by killing his wife because her life was not insured although her mother had left her a small legacy. It emerged that at the time of her death he had yet another lover. Did he kill Mary so that he could marry this other woman? How did he think he could possibly get away with it?

From the point of view of forensic science, it is difficult to understand why Pritchard used both aconite and antimony. Aconite is derived from the familiar garden plant Aconitum anglicum which has many common names but is probably best known as monkshood. The active constituent of aconite is an alkaloid called aconitine found in the plant's foliage and roots and a tincture containing aconitine was formerly used to give some relief from sciatica and rheumatism. It is an exceptionally toxic substance. One fiftieth of a grain could bring about death which usually results from failure of the respiratory organs. Arsenic, at least in the popular imagination, is the classic substance used by poisoners. The symptoms it causes vary widely according to the form and dose

This can be found in Grange Cemetery in the Southside.

Tuberous root

This perennial herb is fortunately rare in Britain. It is probably the most poisonous of all British plants and only 10 grams of the root is sufficient to be lethal. It grows on the banks of shades streams and also in deciduous woods.

which is administered and death by arsenic poisoning is easy to detect. From the point of view of those using it for the purpose of murder, it has the advantage of being highly virulent and easily administered, especially in food for it has little taste.

The Grange Cemetery stands in some of the finest suburban surroundings in the Southside. To see a headstone which recalls the Pritchard murders, the visitor should enter the cemetery by the eastern gate in Grange Road. Proceeding straight ahead, a number of stones can be seen attached to the wall alongside which runs Lovers' Loan. The fifth one along bears an inscription to the effect that buried close by are three members of the Taylor family. They are Pritchard's father-in-law, who outlived the others by two years, and his mother-in-law and his wife. In such an idyllic spot, it seems hard to think that this worn stone refers to the victims of a cold-blooded and callous murder that created such an enormous sensation back in 1865.

HIGGINS AND HIS TWO BOYS

Adipocere is something which thankfully few people ever see. It is the result of a process called 'saponification' which occurs when a body has been immersed in water or buried in damp soil over a long period. The normally semi-liquid body fats are hydrogenised into a substance that is quite hard, not unlike suet and is yellowy white in colour. The state of the adipocere can provide a rough indication of the time of death. A build-up of adipocere may protect the internal organs. It certainly did so in the case of the Hopetoun Quarry victims.

Winchburgh is a few miles west of Edinburgh and was at the centre of oil shale extraction operations in an area badly disfigured by the bings or heaps of spoil created by the industry. One sweltering June afternoon in 1913 two men were walking in this ravaged landscape when they decided to sit in the shade provided by some trees on the edge of Hopetoun Quarry. They noticed a bundle in the water which at first they thought was probably a scarecrow someone had thrown into the water. Their interest aroused, they got sticks and guided it to the bank. Not a scarecrow. It was two diminutive human bodies closely tied together. The authorities were called and the pathetic little corpses were taken to Linlithgow mortuary. They were two boys and they had clearly been in the water a long time and were badly decomposed. Death was estimated as having taken place about a year and a half earlier.

Forensic investigation was assisted by the fact that the conversion of the body fats of both boys into adipocere was almost complete and this had had the effect of preserving the internal organs remarkably well. It was even possible to establish that their last meal had been Scotch broth eaten about an hour before they died. This strongly suggested that they had been local to the area and had been lured to the quarry perhaps by a relative or friend.

The police files quickly showed that two boys had disappeared in November 1911 – just the right time judging by the physical evidence. As investigations continued, it became evident that they were the sons of a feckless ne'er-do-well by the name of Higgins. He spent most of his waking hours drunk and had so neglected his family that his wife had died shortly before, leaving him in charge of the two small boys. He did a couple of short terms in prison as punishment because of the way in which he neglected them. Eventually Higgins seems to have lost patience with those in authority and others who told him that his treatment of the boys was inexcusable and he took them to the quarry where he ended their lives. He then concocted various cock and bull stories to account for their disappearance but he was arrested and charged with murder. His defence when he was tried in Edinburgh was temporary insanity caused by epilepsy but this cut little ice and he was found guilty and sentenced to death. He showed no remorse and was hanged at the prison at Calton Hill on 2 October 1913.

MERRETT, ALSO KNOWN AS CHESNEY

One of Edinburgh's adopted sons was also one of the city's most celebrated murderers. John Donald Merrett was born in New Zealand in 1908. In 1924 his father abandoned him and his mother whereupon she came back to England, the land of her birth, accompanied by her only son. Mrs Merrett was comfortably off and sent the youth to Malvern College, a prestigious public school. Being intelligent, charming, enthusiastic and likeable, young Merrett had all the makings of a professional fraudster. He was especially good at languages and managed to get good marks for his schoolwork despite appearing to make little effort. He discovered girls at an early age and his natural plausibility meant that he talked himself into bed with significant numbers of them. Inevitably this caused problems and some scandal and led to Mrs Merrett being asked to remove her son from the school roll.

They moved to Edinburgh and a first floor flat at 31 Buckingham Terrace, Queensferry Road. Merrett enrolled at the university to study art at night school but quickly lost interest in things academic and threw himself instead into things hedonistic. These always seemed to involve good-time girls, many of whom were professional dancers. Consorting with these bons vivants could be expensive and in order to fund his pleasures, he started forging his mother's signature on cheques. He was good at it. He had fraudulently drawn twenty-nine cheques amounting to £458 on two of her accounts but failed to make the round thirty because the bank manager wrote to his mother expressing concern about the growing size of her overdraft. She seemed somewhat bemused, apparently not fully appreciating what her son had done. Merrett, however, was chastened by the experience. He realised that he would not be able to forge any more cheques, at least for a while. But how would he fund his fun with his female friends?

Merrett shot his mother, attempting to make it look like suicide but bungled the job because she regained consciousness. However, she was unable to give any coherent account of what had happened although Merrett 'explained' that his mother had financial worries. A couple of weeks later, Mrs Merrett died and the police began to be suspicious after they had found one of her cheque books in his room. Inquiries followed at her bank and the small matter of the twenty-nine forgeries came to their attention. It was evident that Merrett lived beyond his means. It also emerged that in the event of his mother's death, he stood to inherit her annual income. The police had a motive and they charged Merrett with murder.

He was tried at the High Court of Justiciary, Parliament Square, Edinburgh, in February 1927. The jury found the case against him for murder 'not proven'. He received a custodial sentence, however, for forging the cheques. While he was in prison, he had a visit from a Mrs Bonnar. She was a friend of his late mother and did not believe that Merrett had murdered her. When he was released, he changed his name to Chesney and went to stay at Mrs Bonnar's home in Hastings. Soon afterwards he eloped with and married her daughter Isobel who always went by the name of Vera. Then a lovely plum fell into Chesney's lap – an unexpected legacy of £50,000 from his grandfather. Seemingly an uxorious husband, he settled £8,400 of this on his wife. This arrangement was to become of significance some years later.

He systematically spent his legacy while trying his hand at various criminal activities. These included theft, smuggling, blackmail, forgery and fraud and, to give him his due, he displayed considerable flare in every one of these departments. During the Second World War, he served in the Royal Navy Volunteer Reserve and managed to combine smuggling with his official duties until he was captured by the Italians and became a prisoner-of-war. Being something of a spiv and an opportunist, he made a lot of money in black-market activities in the chaos that was Germany in the immediate post-war years. Despite his earnings, it never occurred to him to save for a rainy day and by 1954 he was broke. Then he remembered the £8,400 he had, with uncharacteristic generosity, given to his wife over twenty years earlier. If he was to get his hands on that money, it would significantly ease his cash flow problems. To do so, he would need to murder her.

He had seen little of Vera for some years, enjoying the favours of a succession of mistresses, but he kept on a friendly if somewhat distant basis with her. He was actually living in Germany. She was therefore rather surprised when in February 1954 he suddenly turned up at the residential home for old people that she and her mother ran, close to Ealing Broadway in West London. Not only did he arrive out of the blue but he was all over her, taking her out for an expensive dinner and buying her one gin and tonic after another. He had obviously remembered that this was her favourite tipple and it was almost like old times.

Back he went to Germany but he then turned up again. This time he flattered her, got her drunk, came back to the residential home, pulled her into a bathroom and drowned

Donald Chesney, an unscrupulous confidence trickster and murderer.

her in the bath. The £8,400 was now his! Her mother, who by now had become very suspicious of his motives, challenged him as he was making his way out of the building. He decided that she knew too much and so he murdered her as well. Chesney then fled but an international alert had been put out on him and, feeling the net closing in and having nowhere to go, he shot himself. Before he did so, he had told his latest flame back in Germany that his name was Donald Merrett and that a quarter of a century earlier, he had murdered his mother. He was a thoroughly bad lot. Edinburgh has no need to be ashamed of him. He came there from England.

CHAPTER 8

The City under the City

The good citizens of Edinburgh and the many visitors to the city have long been fascinated by rumours that the city boasts a labyrinth of secret underground tunnels, passageways, cellars and indeed whole streets of houses. Stories have circulated and they have attracted amateur archaeologists, local historians and the plain and simply nosy. So what is the truth about the 'Underground City'?

The High Street or Royal Mile forms the historic heart of Edinburgh and it still has the ability to fascinate with its hotchpotch of old and not-so-old buildings, some of which qualify as multi-storey buildings, their form necessitated by the narrow spine of volcanic rock along which the High Street runs. What we do know is that as well as building up, ancient Edinborians also burrowed down to make housing and other accommodation. A mass of stories have grown up associated with these places. Many of them concern foul deeds, hauntings and witchcraft.

The Royal Mile is very much about change and changelessness. The High Kirk of St Giles, often mistakenly called St Giles's Cathedral, continues to dominate while at the Mercat Cross Royal proclamations are made as they have been for centuries. The notorious Tolbooth has vanished although there a heart-shaped stone set into the pavement shows where it used to be. On the north side of the Royal Mile one example of a relatively newer building which has a dominating presence is the City Chambers, built in 1753.

Especially on the south side of the High Street there is a mass of closes and wynds which nowadays have nameplates and they mostly take their name from those of prominent citizens who formerly lived there. In earlier times, these closes would not have had any visible nameplates and they changed their names with some frequency as and when their most celebrated inhabitant died. Then a new name would emerge. It must have been extremely confusing. There are at least four other recorded names for what was long known as Alexander King's Close, the man himself a successful and rich lawyer who died in 1619. However, he was not a man who was liked. Edinburgh folk used to reckon that he had dealings with the Devil or at the very least that he was involved in witchcraft. When they could, they gave his house in the close a wide berth. This reputation may simply have been because King was a practicing Catholic at a time when Scotland

was staunchly, even militantly Protestant and anything that could be used to isolate and demonise Catholics was regarded as perfectly fair. By the early seventeenth century, the close had an evil reputation.

We know from records that in 1635 a new resident of the close was Mary King (no relation). She was a widow with three children and her husband had been a local citizen of some substance. Much is known about Mary King because of an inventory of her possessions which is in the Scottish Records Office. It is interesting to note the extremely large quantity of wine, whisky and beer listed in this inventory, far more than you would expect a respectable middle-aged widow to have stashed away – far more than the occasional dram taken to keep out the icy Edinburgh winter winds.

The close in which she lived ran down the steep slope to the Nor' Loch. The origin of this stretch of water covering much of what is now Waverley Station and the various railway lines leading into it, was as a kind of moat defending the northern approach to the Old Town. By the sixteenth century it was nothing better than an open stinking sewer acting as a convenient receptacle for all the rubbish produced by the inhabitants of the High Street above. During warm summers, the smell of this fetid lake was simply indescribable. When it was drained for the building of the railway, it was found to contain the remains of hundreds of dead bodies.

In those days both rich and poor lived cheek-by-jowl sharing the same front door. The general rule of thumb was that the better-off lived higher up in reasonable apartments while some of the poorer people inhabited dingy underground one-roomed laigh or low houses, basically cellars.

Edinburgh was notorious for its pestilence which was encouraged by the poor penetration of sunlight into many of the wynds and closes and by the overcrowding, poverty, squalor and filth endured by much of the local population. In 1645 the Old Town was ravaged by an awful outbreak of bubonic plague which cut swathes through the local population. Nothing was known about the microscopic pathogens of disease and the terrified population cast around in desperation looking for someone to blame. Was it God's anger with human sin? Was it brought by English soldiers? Would it only stop once the entire population was wiped out? Eventually the decision was to close the gates or ports as they were called to the Old Town and to carry on in virtual quarantine. By this time the inhabitants had discovered the cleansing power of fire and had made huge bonfires of the clothes and other possessions of the dead. The heat was of course killing the fleas that transmitted the disease. The plague lasted for about a year and deaths were running at such levels that special mass graves were created in the Meadows and Holyrood Park. Mary King's Close was as badly affected as anywhere being among the most overcrowded and rat-infested parts of the town. So many deaths occurred there that the victims were carted off to be buried at Bruntsfield Links about a mile to the south. Large numbers of the dwellings in Mary King's Close were empty – sometimes entire households had been wiped out. Rumours began to circulate that there was a population of ghosts to replace the human residents.

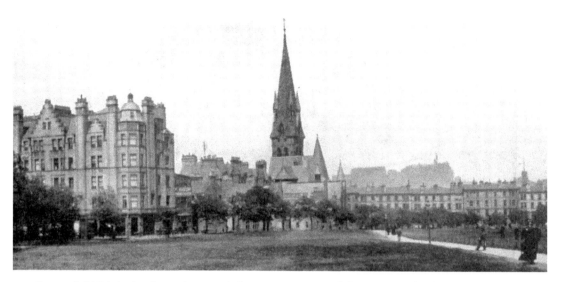

Bruntsfield Links in the early twentieth century. Many of the victims of infectious epidemics were buried under this much-loved open space south-west of the city centre. It was probably here that the troops gathered before heading off to the killing fields at Flodden in 1513.

In 1685 a book was published with the title *Satan's Invisible World Discovered*, written by a professor from Glasgow University and claiming to have 'proved' the existence of devils, witches and ghostly apparitions in the Old Town. It was just the right combination of scaremongering, sensationalism, gruesome detail and moral outrage that would gladden the heart of the editor of any of today's tabloid newspapers. It was a farrago of tales of wizards, disembodied noises, headless apparitions and even a bodiless arm which had the disconcerting habit of floating in and out of certain of the closes and wynds in the Old Town.

It has to be said that the author, George Sinclair, was no dispassionate chronicler of strange phenomena but something of a religious maniac who believed that humanity as a whole and Edinborians in particular had strayed too far from the path of God and that they needed to be scared into more upright ways. He did seem to have it in for the people of Edinburgh and some commentators have ascribed this to the well-known and long-standing antipathy that Glaswegians have displayed for the citizens of 'Auld Reekie'. It has to be said, of course, that this dislike is heartily reciprocated.

Deeply flawed so far as accuracy was concerned, this book enormously amplified myths that were already in the process of developing and many of which have somehow come through to the present time. One of the places he singled out as particularly ungodly was of course Mary King's Close. When a number of serious fires broke out there in the early years of the eighteenth century, knowing looks and nods were exchanged and tongues wagged. Clearly there was still mischief and ungodliness afoot in the close.

Eighteenth-century Edinburgh was booming and parts of Mary King's Close were demolished to make way for new buildings such as coffee houses, various other businesses and a merchants' trading hall, an early example, if you like, of gentrification. In 1856 a new thoroughfare was built, Cockburn Street, to join the High Street to Waverley Bridge and the New Town. This was also built with the intention of opening up and demolishing a rookery of squalid slums and so it was that the northern end of Mary King's Close disappeared. All that remained was under the building now called the City Chambers. What was left of Mary King's Close had a number of shops in it. The City Council decided that they didn't want even this evidence of the Old Town's seedy past and it decided to encourage these businesses to leave. So there are still many underground staircases, rooms and workshops which are what is left of a once notorious close. Over the years they have been used for the storage of archives, as offices for the City Council and during the Second World War as air raid shelters. In recent years they have increasingly attracted seekers of the odd, unusual and macabre. They have been added to the lengthy list of Edinburgh's tourist attractions.

Now this may all seem rather tame and even an anti-climax but while the area may have been sanitized, the stories have grown and grown. Here is a sample of the stories from recent years. First is the Lady in Black. Many of the workers in the City Chambers claim to have witnessed a tall woman in old-fashioned long black or brown clothes. She is not particularly threatening but there is no point in trying to chase and catch her because like any self-respecting ghost, she simply melts away. Some say this is the ghost of Mary King herself but others think she is a Victorian phenomenon. Another regular in Mary King's Close is a short gentleman in late middle age who struts around with a vaguely agitated air and has been seen by many council workers and by some people on tours.

Some years ago a number of council employees decided to stay underground for a night, being sponsored to do so to raise money for charity. They equipped themselves with mattresses and sleeping bags and settled down for what they hoped was going to be a peaceful night. It wasn't! Although no frightful phantoms appeared, rattling their chains or chattering their spectral teeth, they were kept awake for much of the night by the sounds of conviviality from close by. Until around three in the morning the clinking of glasses, buzz of animated conversation and occasional bursts of uproarious laughter kept them awake. Following up in the morning, they were hardly reassured to be told that there were no places near enough for the sounds of partying to be heard.

The best-known of the ghostly stories attached to the area around Mary King's Close is that of the Little Girl. This apparition has been seen on a number of occasions and consists of a small ragged child with dirty long hair and who is crying. A psychic claims to have got in touch with this little ghost and found out that it was a very young girl who died in the plague of 1645. Before she had died she had lost her doll in the confusion and that is why she is crying, presumably never having had it back. There are large numbers of dolls and teddies that well-wishers or gullible plonkers, depending on personal point of view, have placed there in an attempt to propitiate the little girl and let her spirit rest at last.

The stories of strange sightings in Mary King's Close have attracted numbers of psychic investigators over the years. However the phenomena noted by those working in the area have certainly recorded an unusually rich list of slightly spooky phenomena, enough for any psychic investigators. Electric fires switch on with no apparent human agency, lights fuse with tedious regularity even after extensive rewiring was undertaken. Lights go on and off for no good reason and on one occasion an electric drill, left by workmen for the weekend, suddenly burst into life despite the fact that no one was close enough to switch it on. The tour guides who show groups around what is left of Mary King's Close comment on how often the lights flicker or even give out altogether for a second or two. Needless to say, the sense of manageable terror that this engenders is always useful for making people feel they have had good value for money on an expensive tour.

Moving on from Mary King's Close and its subterranean associations, we must bear in mind that stories that have circulated from time to time about entire subterranean cities lying under Edinburgh are complete nonsense. There is not and never has been a system of inhabited caves because the hard igneous rock on which the Old Town is built quite simply cannot contain natural caves nor can it allow artificially man-made excavations for anything more than the foundations of buildings. The subterranean dwellings and other human uses of space below ground are there because of the topography of the area which means that the Old Town stood, indeed still stands today, on a largely east to west steep-sided cliff from which at one time bridges, viaducts, call them what you will, provided a link to the land standing to both the north and the south. The South Bridge was built over 200 years ago to link the High Street with the emerging suburbs in what became known as the Southside. Of its time, the building of the South Bridge was a considerable success in terms of civil engineering. Beneath the shops and the road stand nineteen massive stone arches that support the bridge. Although there is really nothing to see from the outside, these arches contain an extensive network of vaults, tunnels, passages and damp underground chambers. Some of these have only recently been discovered. More may follow.

Although the buildings that were there before South Bridge was erected included many that were medieval, few traces of these survive because they were demolished and much of the stone used to build the bridge itself. Among streets that were destroyed were some of the most historic in the Old Town. Almost all traces of Niddry's Wynd, Lockhart's Court and Marlin's Wynd have long since disappeared. Gruesome stories have been attached to all these places and it takes no great leap of the imagination in what is still a highly atmospheric part of the city to visualize the seedy, teeming life of the area at least up to the eighteenth century.

If you stand in Cowgate and look up, you can see that one of the arches was kept open to allow the Cowgate itself to pass underneath. Up on the bridge, elegant shops and houses were built and the arches acted as vaults or undercrofts for these with storage facilities and, in some cases, accommodation for servants. It is not impossible that the odd

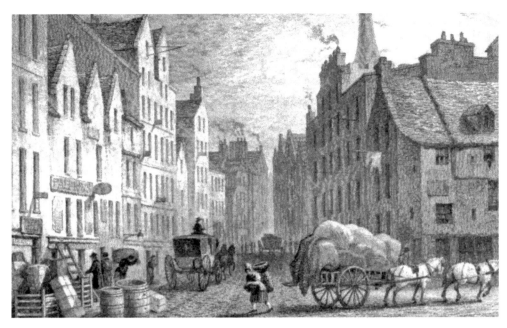

Cowgate is a gloomy street which runs under South Bridge and even today it gives some sense of the insalubrious nature of much of the Old town.

illicit whisky still may have been found down there. In fact at least one did come to the attention of the authorities. What about the others?

As with Mary King's Close, some of the space under the South Bridge was used for air raid shelters in the Second World War. Many of those who could have used them preferred to take their chances up on top because of what were described as the spooky sensations down below. Inexplicable noises, shadows that moved and presumably things that went bump in the night, they were all guaranteed to prevent a decent night's sleep.

In recent years as interest in underground Edinburgh has increased, psychic and paranormal investigators have spent time down below the South Bridge and recorded a host of curious or inexplicable phenomena. One of them is a boy of about five or six who joins tour parties although he doesn't pay the fee. He is harmless but apparently likes to appear and disappear and sometimes when he is in invisible mode, he gets fun from tugging at people's sleeves. Some people claim that he tries to hold their hands.

More sinister is a disembodied older man who apparently resents the presence of visitors and shows his resentment by breathing hot air down their necks and occasionally he is heard telling them in a gruff voice that he wishes to be alone. Is he the same man in a tricorn hat who makes occasional appearances? It hardly needs to be said that footsteps and sinister laughter have been heard by guides and tourists. It's all good for business. We shouldn't begrudge it.

CHAPTER 9

The Body-snatchers — Burke and Hare

William Burke (1792-1829) gave his name to 'burking' or body-snatching and with his equally egregious partner-in-crime, William Hare (died c.1860), forms a duet inextricably linked with Edinburgh's murky past. Grave-robbing and body-snatching are two of the most macabre crimes known to man and both were prevalent in Edinburgh in the eighteenth century and the first decades of the nineteenth. The low-life characters who engaged in these crimes elicited particular loathing and revulsion at the time and have continued to exercise a morbid fascination ever since. Such people have been known as 'body-snatchers', 'resurrectionists' and 'sack-em up men'. Strictly speaking the word 'body-snatching' applies only to those criminals who stole cadavers before they had been buried or who murdered in order to obtain corpses that they then offered for sale. Burke and Hare were not resurrectionists: not for them were the travails associated with nocturnal visits to graveyards and the exhumation and transporting away of freshly-buried corpses. Nor were they, strictly-speaking, body-snatchers. Putting it plainly and simply, they were murderers.

Inevitably any discussion of this subject raises issues of religion and superstition attached to the greatest mystery of life which is, of course, death. The practices surrounding bereavement are a part of popular culture and they have varied enormously over time. At the time we are looking at, attitudes were strongly flavoured by a belief that that there was a connection between the body and the soul for an indefinite period after death — in other words that an unburied corpse was in a kind of intermediate place, a limbo between being completely alive and completely dead. This meant that the deceased were frequently watched after death and before burial for any sign of returning life. Food and drink were often placed near the deceased for its sustenance if it came back to life. In Scotland and the north of England the practices surrounding death were a mixture of pagan and Christian. An example of this was 'sin-eating'. This was done by the local sin-eater who was not a member of the family. He was brought in for the occasion and would publicly and ritually eat a piece of food which had been placed on the body of the deceased. The person who did this was often referred to as the 'scapegoat' and by consuming the piece of food, he was symbolically taking over the sins of the deceased thus releasing the latter's soul for entry to paradise.

It was believed that there were demons around who wished to make off with the soul of the deceased while the body was still unburied. This was a reason for having a wake. It was a noisy affair with a large crowd of relations and neighbours and took place in the room occupied by the deceased. They ate well and drank well and as they did, obviously noise levels would increase, the intention being that this would help to scare off the demons. In some places, they 'trounced' the corpse. This involved it being picked up and swung backwards and forwards accompanied by screams, screeches and the banging off pots and pans. Again the noise was supposed to deter the demons and keep them away. The tolling of a bell at the funeral was also supposed to prevent unwanted demonic attention. This idea that the corpse was not quite dead yet not quite alive is shown also by the belief that if the corpse's eyes didn't close, further deaths in the family were imminent.

Even people who lived in the direst poverty believed that it was essential for a relative to have a dignified funeral and every effort would be made to ensure this happened even if it meant pawning necessities or not paying outstanding debts. Getting the money together to pay for the funeral might take several days and during that time the corpse would be housed at home, often in the front room of the house or in the back room of a pub, for example. It is worth bearing in mind that the funeral and most things associated with it were examples of what might be described as 'community self-help'. In other words they were carried out by family, friends and neighbours. The profession of funeral director only emerged later in Victorian Britain and the prices they charged were way beyond the pockets of the poor anyway. So the provision of a coffin and the transport to the place of interment was paid for and carried out by the relatives.

When the body had been cleaned and laid out, 'viewing' took place. Not only relatives, neighbours and friends would then cram into the house but others from the district who had never even known the deceased. This practice was on the one hand a ritual paying of last respects but it was also a form of free entertainment. It provided the entry to a house which they would not normally have access to. Those coming to pay their respects could also have a good gawp at the furniture and fittings as well as seeing what kind of job had been made of laying the corpse out. Viewing was therefore clearly great fun for those of a nosy disposition.

As late as the nineteenth century, the poor were usually buried without a coffin, in a winding sheet arranged so that the face could be viewed before burial. The rich, however, were usually placed in a shroud and then deposited in a coffin. It was customary for all classes to place herbs with the corpse. These herbs were symbolic of emotions. For example, rosemary for fidelity, yew for sorrow, rue for pity and box for everlasting love.

Turning from some of the social customs relating to bereavement, let us now move on to look at the cadaver from the point of view of the medical profession. The study of anatomy requires in those who practice it what may be described as 'clinical detachment'. This is a suppression of the normal physical and emotional responses to the bodies of the dead. This clinical detachment enables practitioners to carry out tasks which under normal

conditions would be taboo or physically repugnant. We expect the practitioner to be professional, objective and emotionally uninvolved. An early example of this detachment in the interests of science and humanity was William Harvey. While researching his theory about the circulation of the blood in the 1620s, he performed dozens of autopsies including two on his own father and sister.

By the middle of the eighteenth century, significant advances were being made in science and in medicine and the study of anatomy in particular. For centuries doctors and surgeons had been held back from developing their knowledge of anatomy by the power of the Church which disapproved of the dissection of human bodies on the grounds that it involved tampering with bodies created in the image of God. It was widely held although not probably with any ecclesiastical sanction that if a dead person was tampered with even to the extent of just having a toe removed, he or she was incomplete. On the Day of Judgement they would therefore not be able to enter Heaven and were condemned to roam for ever, unable to rest, like the Flying Dutchman.

The power of the Church was waning in the eighteenth century but these ideas still had potency. As so often happens, it was those people at the bottom end of the social ladder who were utilised without their permission in the cause of scientific progress. Legislation was passed allowing the release of a small number of hanged felons every year which were given to the Company of Surgeons in Edinburgh and London. This was regarded as an aggravated punishment for the felons concerned, going to their death knowing that that their mortal remains would be exposed to gaze and mutilation and that they would be denied a decent burial. In practice, some surgeons were also able to acquire corpses semi-legally from poorhouses and prisons where no relatives or friends came forward to claim them when they died.

The problem was that the thrust of scientific advance was being hampered by the shortage of what might be described as legal and suitable specimens. The dissection of corpses was necessary because it would increase knowledge of anatomy as a whole and provide vital object lessons for medical students, especially those aspiring to be surgeons. Most of the medical schools were in Scotland but there were some also in London and Dublin. They were run entirely on a private basis. The legal and semi-legal sources of cadavers were unable to keep pace with the demand and a busy trade developed importing corpses from the Continent, no questions asked. Obviously these couldn't be brought into the country in crates marked, 'Corpse, please handle with care'. Other descriptions of the contents were needed so as not to draw attention to them.

In the period 1805 to 1820, 1150 criminals were executed in Britain – about seventy a year on average only a handful of whom were released to the schools of surgery. It was more difficult to import bodies during the wars that occupied much of that period and so during the first decades of the nineteenth century the thousands of students who passed through medical and surgical schools annually practised on bodies most of which had been obtained totally illegally. Some were indeed still imported illicitly but many of the

others had been stolen before burial, wrenched out of coffins in newly dug graves in the witching hours of the night or in some cases were the victims of murderers who had killed in order to obtain a corpse to sell.

We may think it strange that supposedly respectable surgeons turned a totally blind eye to the provenance of the anatomical specimens on which they demonstrated in their lecture theatres but money was to be made teaching in anatomy. Anyway they would have argued that what they were doing was in pursuit of scientific knowledge and better medical and surgical practice. They wanted to further the understanding of how the body worked and to study abnormalities and diseases. They were doing so in the same spirit of scientific enquiry that had led Linnaeus, the great Swedish botanist, for example, to make great advances in our understanding and classification of plants. No one asked him where he got his specimens from so why all the fuss about a few cadavers?

The best prices were usually paid for fresh, young specimens or in some cases for specimens that exhibited strange deformities or the symptoms of interesting diseases. As such they had scarcity value and were particularly useful as object-lessons. Surgeons sometimes heard of the death of people whose corpses were particularly interesting and they would come to a financial arrangement with a gang of criminals in order to obtain such a specific specimen. 'Specimen' was a commonly-used euphemism for corpse as was 'subject'. Sometimes they were referred to as 'things for the surgeon'.

It is probably fair to say that modern surgery in the British Isles started with the brilliant work of John Hunter, a Scotsman who did his greatest work in London. Surgeons were unpopular. The general perception of them and their activities was not helped by the case of Hunter and Charles Byrne, known to all and sundry as 'The Irish Giant' which indeed he was, being over 7 ft 6 ins tall. He made his money touring Britain in a circus with a troupe of other human curiosities and freaks. Delighted crowds gazed in awe at this gentle giant with pleasant and modest manners which made him extremely popular. He had just finished a gruelling tour of the British Isles during which, among other things, he had delighted the inhabitants of Edinburgh by lighting his pipe at their gas street lamps, when the news emerged that he was dying. He was only twenty-two years of age.

John Hunter rather tactlessly let it be known that he wanted to get hold of Byrne's abnormally large skeleton to add to his collection of anatomical specimens that he used for demonstration purposes. Byrne heard about this and gave instructions and a sum of money that his corpse was to be guarded day and night until it was placed in a heavy lead coffin and buried at sea as soon as possible after his death. However Hunter had a deeper pocket that Byrne and they gave those appointed to guard the dead Byrne an offer they couldn't refuse. The outcome was that no sooner was Byrne dead than his body was smuggled out of his lodgings and into those of Hunter. He was after Byrne's skeleton and so he boiled the dead giant, disposing of his flesh and other tissue. Byrne's skeleton can still be seen today in the museum of the Royal College of Surgeons in London. It is still a brownish colour as a result of its boiling by Hunter. This shows the lengths to which the surgeons were prepared to go.

Every corpse, except perhaps those buried in the remotest parts of the land, was vulnerable to the attentions of the resurrectionists. The well-to-do could hire watchmen or iron frames called mortsafes placed over the grave until such time as the human remains were too far gone to be of any use to the anatomists. There are still some mortsafes to be seen in Greyfriars Kirkyard. Sometimes the relatives of the deceased placed spring guns round the vicinity of the grave but the authorities frowned on this practice because there was obviously a possibility that people with innocent intentions might fall foul of these devilish devices.

Curiously enough, the exhuming of a body was not in itself illegal. What was illegal, however, was the taking away of any of the property associated with the corpse such as the shroud or any valuables or keepsakes that might have been buried with it. However few crimes have ever excited such revulsion and the public would give anyone they thought was involved in tampering with graves and bodies very short shrift. The rich could afford the precautions mentioned above and they had little fear of exhumation and ultimate dissection and exhibition in front of a covey of gawping anatomy students. The poor on the other hand lived in dread of this happening to them.

The first resurrectionists were probably anatomy students who in an admirable spirit of self-help decided to assist their own studies by getting hold of corpses freshly buried in the local cemetery. There is a record of one such group of students taking a corpse home by dressing it up in everyday clothes and walking it through the streets in the darkness as if it was one of a group of drunken late-night revellers. Most of the resurrectionists however were gravediggers by trade, mortuary attendants or hospital porters, such men obviously having detailed knowledge of fresh burials and the whereabouts of newly filled graves. While this was lucrative work, it was obviously extremely uncongenial and most of them could only do the work in a state of semi-intoxication.

The resurrectionists always worked in small gangs, allowing at least one person to keep a look-out. With shaded lanterns and using wooden spades and shovels to lessen the noise, they would work as quickly as possible. The main physical effort was hauling the corpse out of the grave, this being by no means an easy task since it was literally a dead weight, no pun intended. Experienced grave robbers placed a canvas sheet by the grave to receive the dug-out soil and to ensure that none of it spilt out onto the surrounding area. It was important to try to leave the grave looking as if it had not been disturbed.

A hole would be dug at the head of the grave down to the coffin and hooks or a crow-bar inserted under the lid. The weight of the earth on the rest of the lid acted as a counter-weight, so that when pressure was exerted, the lid usually splintered or broke in two. With a bit of luck, the body could then be hauled out with ropes. Experienced grave robbers would have placed sacking over the lid beforehand to reduce the sound of the wood splintering. The corpse was then usually trussed up, placed in a sack and trundled away in a hand cart, usually under a legitimate cargo such as firewood.

Occasionally the grave robbers would be in real luck because several fresh bodies might have been buried in the same grave. We know that some London resurrectionists

exhumed and carried away no fewer than sixteen bodies from one communal grave. Sometimes these pits were deep and there is a record of two resurrectionists dying in one that was twenty feet deep. It is thought that the first had fallen in, injuring himself while the second was a would-be rescuer who had managed to fall in on top of him and also injured himself. They probably died from asphyxiation as a result of being unable to move or were poisoned by gases being given off by the decomposing bodies around them.

Lest the reader feels totally overcome with disgust at the activities of the resurrectionists, a thought should be spared for those even worse examples of low-life who exhumed bodies and sold the bones to be ground down for fertiliser or the body fat to be rendered down and used for candles. One little-known aspect of the resurrectionists work was that they often used to remove gold fillings and indeed whole teeth from those they had exhumed. The teeth were wanted for use as dentures by the well-to-do. Apparently real teeth did not stain in the way that false teeth of the time did nor were they as brittle.

Over the years corpses became commodities, being bought and sold just like potatoes. They were touted around, haggled over, they could be delivered to order, they were transported across the country, they were imported and even occasionally exported. They were trussed up in sacks, compressed into trunks, packed in sawdust, squashed into barrels and salted, pickled and injected with preservatives. They were trundled on hand-carts through the ill-lit silent city streets in the depths of the night, carried on slow moving carts and wagons and when relative speed was important, they were even lifted onto and carried on stage coaches. None of this was consonant with the respect that most people feel should as far as possible be extended to the mortal remains of the dead.

Messrs Burke and Hare were body-snatchers and murderers, not resurrectionists. They were a couple of ne'er-do-wells of Irish extraction living in the teeming slums of the Old Town in Tanner's Close which was close to the West Port. Hare and his wife ran a foetid doss-house among whose residents were Burke and his common-law wife. He had arrived in Scotland about 1817 and obtained employment working as a navvy on the Union Canal. Both men worked, when they could be bothered to, as cobblers but because the two of them spent every penny they could on drink, they were permanently broke. Both were of limited intelligence albeit combined with ample cunning and were short-tempered, strong and violent. This *ménage a quatre* had its ups and downs. Sometimes when they were drunk, the four of them were the best of buddies, sentimentally pledging their everlasting friendship. On other occasions the drink took them differently and vicious fights broke out.

Around Christmas, 1827, an old man, one of the other residents of the doss-house, died, rather inconveniently as he was in arrears with his rent, to the considerable tune of £4 (£3 in some accounts). He had no known relatives and so our dynamic duo hit on the idea of selling his corpse to the well-known Doctor Robert Knox (1791-1862) who ran one of the city's anatomy schools and had premises at No.10, Surgeon's Square. Knox was prepared to buy corpses in good condition without asking any awkward questions

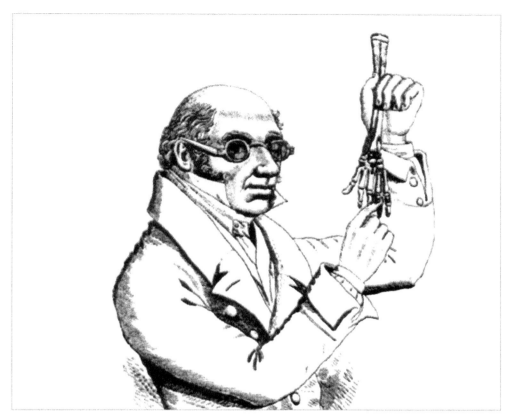

A rather sinister depiction of Dr Knox, the man who eagerly bought cadavers provided for him by Messrs Burke and Hare – no questions asked.

concerning where they came from and how they had been obtained. Their excuse for this bit of skulduggery, if Burke and Hare needed one, was that the money they received for his corpse would recoup the missing rent.

They were gratified and totally amazed when Knox casually offered them £7.10s, congratulated them on their entrepreneurial efforts and told them that it would be a pleasure to do further business in the future. This amount of money must have seemed like a king's ransom, enough to pay for many mammoth drinking sessions. The experience spurred their shifty little minds on to greater thoughts. They realised that there many other inhabitants of these teeming slums who were drifters and derelicts with no friends and relations who, when they died, simply wouldn't be missed because no one cared. It was but one small and logical step from this to turn to murder, again of the quarter's rootless residents. Victim number two was a woman lured to Tanner's Close with the promise of drink and then stifled as she snored. They received £10 for her, the higher price reflecting the fact that her corpse was fresher.

They say that appetite grows with eating and perhaps the lust for murder increases with practice. Another early victim was a Mary Paterson, a red-head of considerable beauty but dissolute character. She was a 'dolly-mop' or part-time prostitute. Before they sold her to Knox, Burke cut her hair off in order to sell it. She was smothered. One of Knox's students was sure that he recognised her, often seeing her around the area. In fact he felt certain that he had seen her only a couple of days previously. He had remarked to a friend what a fine, healthy-looking lassie she was but he didn't seem in the slightest bit nonplussed when she turned up a couple of days later on the anatomist's bench. Dr Knox was so entranced by Mary's naked body, very much a cut above what he was used to, that he employed an artist to do a still-life painting of it before resorting to the scalpel.

One victim followed the other and the two murderers became more careless. Most of their victims were elderly women but they picked on one of the Old Town's best-known street characters. This was a lad of about nineteen fondly known as 'Daft' Jamie Wilson. Because he was something of a simpleton, people made fun of him but gently and although he was big and strong, he was easy-going and happy to talk to anyone so he was well-liked. He was just the sort of person who would be missed but this fact seems to have been lost on Burke and Hare who by now were getting greedy. Jamie put up a real fight and the two murderers had to work hard for their reward that day. Legend has it that Jamie inflicted a powerful bite on Burke's hand and that the injury inflicted supposedly turned into a cancerous growth. Amazingly, no one chose to comment when Jamie's inert body made its due appearance in Knox's lecture theatre.

Perhaps it was greed or maybe the drink getting to them but eventually they became really slapdash. They casually murdered an old Irish woman called Docherty and hid her body under straw in their flat. A couple of hours later a massive drinking bout was embarked upon with neighbours and friends being invited to the squalid Tanner's Close. One by one the guests left, most of them in the advanced stages of inebriation but a married couple called Gray were about to leave when the man happened on the body of the old woman. He was compos mentis enough to resist attempts to buy his silence and he went off to report the find to the authorities. As soon as he had gone, Burke and Hare, thoroughly alarmed as well as extremely drunk, somehow managed to get their acts together sufficiently to deliver Mrs Docherty's body to the premises of Dr Knox.

The police acted quickly and when they examined the old woman's body, the marks clearly showed that she had put up a struggle while she was being set upon. The four of them were arrested but Hare and his wife, showing scant loyalty to their lodgers and fellow-miscreants, turned King's Evidence. Burke and his partner, Helen McDougal, were charged with the murders of Mary Paterson, Daft Jamie and Mrs Docherty. The court found Burke guilty only of Docherty's murder and the charge against McDougal was 'not proven'. Burke was sentenced to death. In all, it is thought that something like sixteen people, mostly no-hopers, were killed by Burke and Hare. One of the victims, a small boy,

was murdered by being broken across his knee by Burke. That provides a measure of just how callous and cold-blooded a killer he actually was.

William Burke was hanged on 28 January 1829 at Liberton Wynd, not far from the scene of many of his crimes. A crowd of 20,000 turned out, baying for his blood. Burke paid the price but with a crowd of that size, there were many who went home afterwards disappointed that they hadn't actually been able to see the deed being done to the hateful Burke. As he was launched into eternity, the crowd cheered, threw hats in the air, clapped their hands and some kissed those closest to them in the throng, even though they were perfect strangers. Justice had been done.

With a nice touch of irony, the punishment was aggravated when, on the next day, Burke was publicly anatomised at the University. There was a riot outside because space was severely limited in the room where the anatomisation took place and it was generally only those who had influence who managed to obtain admission to watch the surgeon perform the dissection. The crowds outside which consisted mostly of students were very angry. After all, why should the so-called great and good have all the fun? The authorities were shaken by this display of passion and later on they allowed carefully controlled groups of well-behaved students to pass through the room and view the exceptionally gory remains of Burke. As well as having had his internal organs displayed for the public gaze, the top of Burke's skull had been sawn away and large amounts of blood had been released, squirting in all directions. Next day the general public were admitted. They filed past all day long, an estimated 25,000 of them. They saw what they wanted and their only regret was that their sheer numbers meant that they were unable to linger and take in the full horror of the human remains in front of them. The authorities had had enough and only one day was given over to the public viewing. Many people who had travelled from far and wide were disappointed the next day when they arrived at the University and were told that the show was over. Out of deference to the continued interest in the body-snatchers, Burke's skeleton was preserved and put on display at the anatomical museum of Edinburgh University.

The revelations in court about the activities of Burke and Hare and the two women with whom they associated aroused universal revulsion across the British Isles and put the three survivors in fear of their lives. Hare left Edinburgh and Scotland attempting to travel in disguise but being recognised time and time again. Wherever he went the authorities had to guard him from vengeful crowds who would have lynched him, torn him to pieces or drowned him in the nearest deep water such were the emotions that his crimes had aroused. He travelled by coach to Dumfries and Annan and the consensus was that he was making for Portpatrick and Ireland. By 8 February, however, he had made it into England and was recognised two miles south of Carlisle. After that, he simply vanished. Or did he? Some say that he made his way to the Midlands where he found employment in a lime works. After some time one of his workmates realised who he was and threw lime in his face which blinded him. He then drifted to London and lived in the frightful rookery

known as St Giles and emerged to eke out a frugal existence as a blind beggar with a pitch near the British Museum. According to this account he became a familiar sight and locals would point him out to strangers as he shuffled about the streets of the district.

The two women involved in the dramas also got out of Edinburgh and it is known that Helen McDougal was recognised and set upon and that some entirely innocent people who just happened to be look-alikes came under attack. The general feeling seems to have been that even if the women had not actually committed the murders, they were complicit in them and should be made to pay the price.

The greatest hatred, however, seems to have been reserved for Dr Knox. There was already widespread antipathy for anatomists and the whole idea of dissection. In an instinctively class conscious way, ordinary Edinborians reasoned that Burke and Hare could not and would not have perpetrated their appalling crimes unless there had been someone willing to buy the resulting cadavers and to turn a blind eye on the matter of where and how those cadavers had been obtained. Everyone knew that it had been Knox who bought the corpses and it was felt that this made him as guilty of murder as Burke and Hare themselves. Yet not one single person among the Edinburgh legal and social elite had suggested putting Knox in the dock, charged with offences in connection with the murders. Wasn't this what would know be called 'cronyism'? Knox was a successful teacher of anatomy, an educated man with friends in high places and those people had decided that Knox should not be judged for his part in the whole gruesome business.

Knox was a superb lecturer and demonstrator and while Burke's trial had been proceeding, business continued much as usual, or actually even better. He was now a celebrity and his fame or should we say notoriety meant that his lectures were even more oversubscribed than normal. His response was to put on more lectures and make more money. However many malicious rumours were circulating and he had received threats of violence. His friends suggested that he should take some of his enemies to law which he refused to do but he did agree to the establishment of a committee mostly composed of people such as doctors and lawyers, who, if not actually friends, were definitely not enemies. This committee which had no official status was to investigate and report on his relationship with Burke and Hare and any complicity he may have had in the murders. When the formation of this committee was announced, it sent the Edinburgh crowd into transports of rage. They predicted that the old boys' network, the smug Edinburgh establishment would produce a whitewash, exonerating Knox from any guilt.

A large crowd assembled at Calton Hill carrying aloft a life-size effigy of the hated Doctor bearing his name, just in case anyone was in doubt as to who the figure represented. Banging drums and dustbin lids and wailing menacingly, they marched to Knox's house in the Newington district. There the effigy was hanged from a convenient tree and then taken down and set alight. It refused to burn whereupon it was torn to pieces. Knox had heard the mob approaching and had taken refuge in the rear of the building and then, with the connivance of the police, he had been allowed to get away. The mob was in a mean

mood and when they realised that Know was not there, they rioted and took to throwing stones, some of which broke his windows. Other mobs surged around the High Street and Canongate without any real purpose although they also created some damage at Knox's premises in Surgeons' Square. The rumour started that he was at Portobello and a crowd amassed there, again bearing an effigy of Knox, wailing and banging tin cans. This was ritually hanged from a handy gibbet.

These marches, gatherings, wailings and bangings were an interesting example of what was known as a 'skimmington' or alternatively as 'rough music'. These were a long-established way in which the populace could express its loathing of someone's conduct or behaviour by a public rally and march usually to the person's place of residence. It was normal to carry an effigy of the 'victim' which was then hanged and often burnt. The march and the gathering outside the premises were accompanied by the banging of objects and the wailing and sometimes screeching and these sounds could be exceedingly menacing. Thomas Hardy provides an example of a skimmington in his novel *The Mayor of Casterbridge* published in 1886 where the ritual is enacted as a public expression of loathing for Michael Henchard who had sold his wife and child.

The predictions of public opinion in Edinburgh that the committee investigating Knox would arrive at a conclusion favourable to the anatomist were borne out. It said that there was no evidence that Knox or his assistants had known that murder had been committed in the procuring of the specimens on which they practised. This facile statement simply beggars belief – some of the corpses were those of young, otherwise reasonably healthy people and were sometimes still warm when they were decanted onto the surgeons' slab. Knox was an intelligent man. Are we to believe that he had some kind of blind spot and was too naïve or too wrapped up in his work to give a thought to the provenance of his specimens and the relationship between them and the uncouth, drunken and dishevelled people who pedalled them? It is fair enough that he was not personally involved in the murders but the readiness with which he bought the specimens without asking questions was a key factor in motivating Burke and Hare to embark on a series of murders. An attempt was made to shift the blame to Knox's assistants who usually had the direct dealings with the body-snatchers, Knox apparently being too busy for such menial work.

Another furore broke out when the findings of the committee were made public but the Edinburgh crowd was capricious and had begun to lose interest. This time the case for and against Knox was largely fought on a more intellectual level in the pages of journals and magazines aimed at the middle classes. However, the affair ultimately did damage Knox. Perhaps his confidence and his didactic skills had taken a battering but there was first a gradual and then a much more marked falling away in the numbers attending his lectures and his applications for prestigious professorships at the University failed at the first hurdle. He went on the road for a while as a peripatetic lecturer and demonstrator without much success and then moved to Glasgow but failed to make a

living there. He eventually moved to London and went on to publish a very successful textbook on anatomy and a book on angling in Scotland. It is clear that members of his profession from the supposedly civilised middle-class were actually more vindictive than the Edinburgh working class mob because he was eventually struck off the roll of fellows of the Royal Society of Edinburgh and had his license to lecture withdrawn by the Royal College of Surgeons of Edinburgh.

The three main players in the seedy drama described in these pages were commemorated in a little verse which was chanted by the street urchins of the Old Town.

Up the close and doon the stair,
But and ben with Burke and Hare
Burke's the butcher, Hare's the thief,
Knox the boy that buys the beef.

It is evident that few crimes provoked such repulsion as grave robbery and the buying and selling of corpses for the purposes of dissection and demonstration. This excerpt from the court-room speech of a prosecuting lawyer at the trial of a resurrectionist in 1822 certainly shows how a member of the legal profession felt about the crime: *For the sake of wicked lucre and gain, the accused did take and carry away the said body and did sell and dispose of the same for the purpose of being dissected, cut in pieces, mangled and destroyed, to the great scandal and disgrace of religion, decency and morality...*This philippic continued in the same vein – the speech actually went on for nearly two hours – but nowhere did the

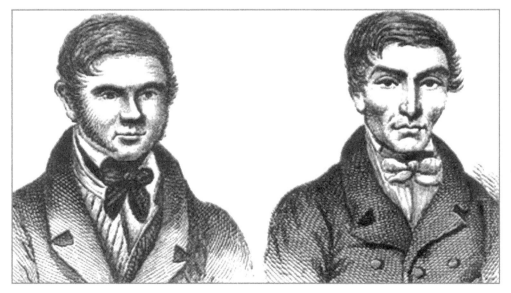

A contemporary picture showing two of Edinburgh's worst scapegraces.

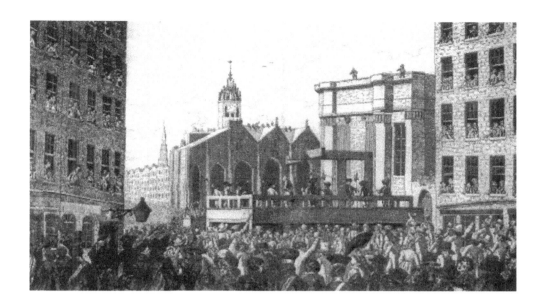

Above: *As was only to be expected, large crowds turned out to watch the death-throes of these repulsive reprobates.*

Right: *A less hostile impression of Knox giving some kind of demonstration.*

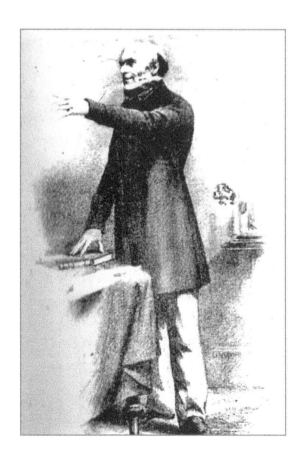

learned counsel make any mention of the person without whose 'lucre' this appalling crime would not have been committed. This, of course, was the anatomist himself.

In the Arab world there is an old proverb, 'barbers learn their trade on the heads of orphans'. This implies that the children have no option but to be used as object lessons. In 1832 Parliament passed a bill which, when it became law was commonly referred to as the 'Cadaver Act'. This made legal the supply of the unclaimed bodies of prisoners and inmates of workhouses to the surgeons and teachers of anatomy. Dissection was thereby institutionalised as an aggravated posthumous punishment for those who had committed criminal offences but in the case of the ex-inmates of poor houses, for poverty as well. It might be argued that poverty has always been regarded as a crime in certain circles but it must have been cold comfort to an expiring pauper with no friends and family to know that his dead body was going to be used for scientific purposes after his death. Poverty in life is hardly a dignified state. In death it is even less so.

CHAPTER 10

Assassination!

Inseparable from any contemplation of historic Edinburgh is the enigmatic and tragic figure of Mary, Queen of Scots (1542-1587). She was born at Linlithgow and became Queen of Scotland at the age of just six days on the death of her father James V. At the age of six she was sent to France with which Scotland had very close ties at the time. She spent her most formative years at the French court and grew up to all intents and purposes as a young French princess and of course an ardent Catholic. When she was eighteen years of age she returned from France. She was already a childless widow having married the sickly and insipid Francis who became King of France at the age of sixteen. He died of meningitis in 1560. She came back to Scotland in 1561, in effect a stranger and her Catholicism meant that she was anathema to many of her Protestant subjects, spearheaded by the loud-mouthed bully, John Knox. Young, attractive, vivacious and a queen, inevitably powerful self-seeking men all across Europe were lining her up as a potential wife. In dynastic terms it was thought imperative that she should marry again and have children. She considered Don Carlos of Spain who was completely unacceptable to her Protestant subjects. It didn't help that he was also an imbecile. There was also the wastrel Robert Dudley, Earl of Leicester, who came into consideration, fortunately not for long. However in July 1565 she married her cousin, Henry Stewart, Lord Darnley (c.1542-67) who was three years younger than herself.

Darnley was handsome in an effeminate sort of way, tall, well-built and possessed of some charm. This was all somewhat superficial because basically he was selfish, egotistical, ambitious, devious and weak. Darnley was described quite kindly by a French cardinal as an agreeable and, only occasionally, a disagreeable nincompoop. He was the great grandson of Henry VI and therefore had a claim on the English throne. He flitted easily to and from Catholicism to Protestantism, having a mother devoted to the first and a father equally avid for the second. Mary had known Darnley for years on and off but only as a cousin. He was something of a fixture around Holyrood when he fell seriously ill. She found herself nursing him through a severe and even life-threatening bout of measles and in so doing fell totally in love with him. Perhaps it was only in looking after him that she found any real purpose in her life.

It didn't take Mary long to realise that she had married a coxcomb, a boring and boorish man who preferred hunting, drinking and roistering with his friends to being in her company. Mary was a cultured young woman who longed for good conversation, for someone of artistic and sensitive temperament, someone against whom, in the nicest way, she could pit her wits and obtain mental stimulus. She found such a man in David Rizzio, an Italian musician and courtier and her personal secretary who, despite being small and deformed, was sensitive, witty and himself highly cultured and of an intellectual bent. He greatly impressed Mary with his ready intelligence, his aptitude for whatever job she gave him and his apparent loyalty and devotion.

The couple spent much time in each other's company, perhaps from Mary's position rather more time than was discreet or appropriate to a queen and young wife. Needless to say, it wasn't long before the tongues started to wag and rumours to circulate that Mary and Rizzio had become lovers. This idea is something which historians haven't taken seriously but Darnley did at least as far as he was capable of taking anything but himself seriously. He flounced around pouting and sulking and since he was so pleased with himself he was quite incapable of understanding how his 'little woman' could possibly enjoy the company of a Savoyard dwarf. For all his arrogance, Darnley was neither very bright nor worldly and various people around the court more cunning than he was sought to play on Darnley's disaffection for their own purposes.

It wasn't just that Darnley took exception to the pleasure his wife so clearly obtained from Rizzio's company. He had another bone to pick with him. To his chagrin Darnley had been refused the Crown Matrimonial although he had the nominal title 'King'. Theoretically this was because of his age but he found himself excluded from exercising any political or administrative power, the privileges he felt his natural talents entitled him to. He believed that this had happened on the advice of none other than Rizzio himself who was known to influence Mary on a wide range of matters. His strong antipathy to Rizzio was common knowledge.

Everyone knows that a band of conspirators burst into Mary's chambers at Holyrood House in March 1566 and pulled out Rizzio and then stabbed him to death. The terrified little man was actually stabbed between fifty-three and sixty times. Some see this event as an attempt by the Protestants to stop what they, wrongly, saw as a rapid move back to Catholicism by killing the Catholic Rizzio who had become the 'power behind the throne'. Others believe that it was also intended to kill Mary herself. She was heavily pregnant at the time.

Now Darnley was among the crowd of conspirators and the best that can be said of him is that even if he didn't actually take part in the murderous attack on Rizzio, he certainly didn't intervene to stop it. The only man who seems to have kept his head while all around him lost theirs' was James Hepburn, Earl of Bothwell, a tough, virile, able, ruthless and self-seeking man who alerted the Edinburgh crowd that there was a threat on the queen's life. This was answered by a mass march on Holyrood House while the

conspirators scattered. These dramatic events did not cause the Queen to miscarry as was perhaps intended and a few months later she gave birth to a son who was the future King James VI of Scotland and King James I of England. Salacious questions were being asked about the paternity of the boy. Some gossipers averred that Rizzio was the father. In some portraits of James as a boy, however, he bears a striking resemblance to Darnley. The conspirators, with the exception of Darnley, were banished. He was ostensibly forgiven but the whole episode only served to widen the breach between Mary and Darnley. Most of the time they simply couldn't stand the sight of each other and it was quite clear that Mary held Darnley at least partly responsible for Rizzio's murder.

Mary didn't have a lot of luck with her men. She was one of those women who longed for a strong man with broad shoulders to take the strain off her. Bothwell had broad shoulders and he began to see a window of opportunity for himself given the partial estrangement between Mary and Darnley. Increasingly he became her confidante and carried out various jobs for her where a firm hand was needed. In a word he began to make himself indispensable to her. In doing this, he was building the power base to which he thought his ambitions entitled him. Bothwell was well-educated and well-travelled. He was a scion of a great border family with ancient roots but for all that he was not a particularly rich man. He was a Catholic but not a very enthusiastic one. He was violent, fiery-tempered, boastful and a sexual adventurer. He exuded a certain brutal vigour and vitality which some women found attractive in an animalistic way. He could be described as a cultured savage. Mary began to be attracted to him in the same inexorable fashion that a moth is attracted to a flame.

Darnley meanwhile was licking his wounds, aggravated that he was increasingly being excluded from all the important issues. The birth of a baby son, assisting the conception of whom being about the only thing that Darnley ever did for Mary, had aggravated him immensely because it greatly reduced the chances of what he really wanted which was to be the sole ruler of Scotland. It only enhanced the growing mutual disenchantment of Mary and Darnley and in the hothouse atmosphere that was Scottish politics rumours started to circulate that Mary and Bothwell were engaged in an adulterous affair. So disenchanted was Darnley by now that he even stayed away from the christening of his son. He went roistering with his mates instead.

In October 1566, Mary, who was staying at Jedburgh, heard that Bothwell was lying injured after some kind of fracas and she resolved to ride to see him in his sinister border fortress of Hermitage Castle, surely the most forbidding castle in Britain. This was perhaps a rather naïve thing to do given that she was a wife and a new mother and in doing this, she only added fuel to the rumours about her relationship with Bothwell. There was talk in the air of a divorce and speculation was rife because Mary, again with consummate indiscretion, had whispered in various people's ears that she would be happy to be rid of Darnley. There were many around the Scottish court who reckoned that they could advance their own positions if Darnley was to meet a premature death. One of these was Bothwell.

In early 1567 Darnley became extremely ill and for public consumption the story was that he was suffering from smallpox. In fact it was probably another pox – syphilis. Darnley's skull in an exhibit in the museum of the Royal College of Surgeons in London and it shows abundant evidence of the damage by advances syphilis. Over the years there must have been many people who gazed at this relic and found in its appearance food for thought.

Mary had come to realize that as long as Darnley was alive, he posed a serious threat to her life and that of her son. His name was constantly being linked with supposed plots and conspiracies against her. Darnley had many enemies and some were undoubtedly thinking about how they might curry favour with Mary and improve their own situations if they could get rid of him. This did not mean, of course, that these people were necessarily favourably disposed towards Mary.

Mary decided that she wanted Darnley to be where she could keep an eye on him. He was brought back from Glasgow where he had been staying and lodged not far from Holyrood in a house called Kirk O' Field. He had made a recovery and Sunday 9 February 1567 had been announced as the official last day of his convalescence. It was also the last Sunday before the beginning of Lent, always a day for rejoicing and carnival. Mary was feeling in a particularly good mood because one of her favourite servants was going to be married and the ceremony was due to take place at Holyrood. Now Mary and Darnley had been getting on a little better of late and she had agreed to spend the evening at Kirk O' Field with Darnley and to enjoy some musical entertainment. However, a messenger turned up to remind Mary that she had promised to be present at the wedding breakfast at Holyrood. Mary apologised to her husband and hurried away. Darnley was insulted, perhaps for once with some justification and he assuaged his irritation by having a few more drinks. Mary left Kirk O'Field and her husband's presence for the very last time. Did she or did she not know that she had very literally been sitting on a time bomb?

Mary presided at the celebrations at Holyrood and then took herself off to bed. Darnley was in his own bed at Kirk O'Field when it seems that he woke up with a premonition of danger. He got dressed, called his trusted manservant and the two of them then let themselves out of the house. This was at about two in the morning. They were less than a hundred yards away when the night air was rent by a massive explosion which reduced Kirk O' Field to a heap of rubble. The bodies of Darnley, clad only in his nightshirt and his servant were found close by in the garden, apparently killed by the blast but some thoughtful person had made sure by strangling them as well. It is not absolutely clear whether or not they were strangled before the explosion. Their bodies showed no other signs of violence. Darnley was dead, aged just twenty. This is one description of what happened that night. Other descriptions have been put forward. Murder of those around the Scottish court was by no means unknown – usually a dagger in the ribs did the trick.

The explosion woke Mary – indeed it probably woke the whole of Edinburgh. Mary was clearly shocked and horrified when she was told what had happened but her feelings must have been leavened with relief that she had left Kirk O' Field before the explosion. It was a sobering thought that someone out there hated Darnley enough to do such an appalling thing. Bothwell was quickly informed of what had happened – if we assume he did not already know and he hurried to take control of the panic that had broken out. He was the Sheriff of Edinburgh. Rumour and counter-rumour rolled backwards and forwards. Foreigners were to blame. Bothwell was to blame – even Mary was implicated. The circumstantial evidence of course was with her conveniently leaving Darnley's presence. Her friends counselled her to take immediate action to detect and punish the perpetrators of this atrocity but Mary seemed curiously numbed, perhaps not altogether surprising given that she was now a widow for the second time and only aged twenty!

But who could Mary trust? She saw herself entirely with justification as surrounded by ruthless, ambitious and perfidious so-called nobles. Where was there a pair of broad shoulders on which she could lean? She found them needless to say in Bothwell, notwithstanding the fact that he was the chief suspect in the murder of Darnley. He most certainly had the motive for murdering him even if he could prove, which he actually could, that he was nowhere near Kirk O' Field when the explosion occurred. Rumours intensified concerning a relationship between Mary and Bothwell and it is very easy to see how the murder of Darnley was the work of the two of them. After all, Darnley was in the way. Only three months after Darnley's death, Mary married Bothwell. It was a serious error of judgment to marry the chief suspect of her own husband's murder but then Mary's adult life seems to have been a train of misjudgements.

Kirk O' Field was a small house, actually a remnant of a monastery, situated near what are now called the 'Old Buildings' of Edinburgh University close to the junction of College Street and Nicholson Street. It is evident that the cellar had been stuffed to the gunwales with gunpowder and that some unknown hand – some think it was a hired hitman by the name of Sir James Balfour – caused the actual detonation. He was thought to be the leader of a small gang who had somehow managed to stash the gunpowder in the cellar without anyone noticing. Although it sounds rather unlikely that they could have done this without being detected, the fact of the explosion means that they did manage it somehow.

Mystery has continued to surround the identity of the assassins and credulity is seriously stretched by the idea that they either strangled their victims knowing that the house could blow up within seconds or that they returned within minutes to strangle their victims before the dust had settled when, of course, alarmed citizens would have been rushing to the scene. One theory, among many, is that Darnley and his servant who, incidentally slept in the same room as his master, were strangled and that the explosion was timed to occur shortly afterwards. It would have been coolly efficient assassins who broke into the house without detection, strangled both men, set a fuse for the explosion and then took

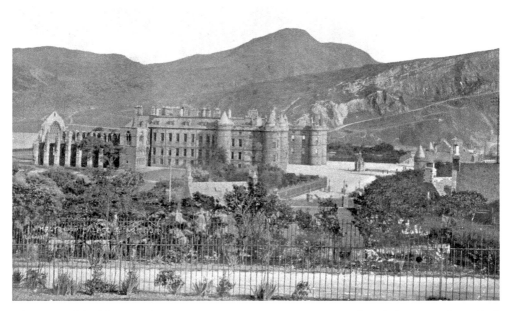

The original building on this site was an Augustinian monastery founded in 1128 but which gradually evolved into a royal palace continuously being added to and updated. As might be expected, it had a turbulent history, none more so than in the time when Mary, Queen of Scots made it her abode.

the bodies outside and deposited them close by in such a way that they looked as if they had gone up with the building and died by the effects of the blast.

A number of suspects were arrested and tortured, as was normal procedure, and many of them subsequently admitted responsibility, individually or in conjunction with others. By the time the authorities had decided to call off further enquiries, well over thirty men had admitted to causing the explosion. If nothing else, this only goes to prove that people will admit to anything they think their interrogators want to hear when they are being tortured and terrified of further excruciating pain. Historians are almost as fascinated by Kirk O' Field and the death of Darnley as they are by Jack the Ripper and books continue to be published providing the final solution to the mystery. The reality, of course, is that we will never know. What we do know was that thereon it was downhill all the way for Mary.

CHAPTER 11

Weir the Warlock

In 1599 a baby boy was born at Carluke overlooking the Clyde Valley in Lanarkshire. He was christened Thomas and his surname was Weir. In view of later developments, it is not surprising that his mother was a well-known sorceress and that his sister, Jean, established something of a reputation in the same department.

Weir went on to become Scotland's most notorious warlock and perhaps the only warlock ever to reach the elevated heights of the rank of major. He served with Cromwell's hated army in Ireland and with the Covenanters against the royalist Montrose. He was a fanatical hater of anything to do with the Royalists or with Catholics and had shown little compassion in his dealings with them. By around 1650 he had become the Captain of Edinburgh's City Guard. This organisation can best be described as a self-perpetuating body of mostly middling citizens who acted as a kind of police force, always keen to use violence backed up with the force of the law against the so-called lower orders of Edinburgh. Many of the Guard had seen military service and were of an age where they had been pensioned off from active service. They were not particularly effective in the discharge of their official duties and were widely disliked as meddlesome bullies.

However it is with his life after he left his public post that we are most concerned. He went to live in the West Bow, a steep street which still connects the High Street with the Grassmarket although the buildings have been totally rebuilt. There he developed a reputation as a Protestant zealot whose knowledge of and ability to quote the Holy Scriptures became legendary. He and his sister were part of a small, exclusive sect called the Bowhead Saints who met for worship in each other's houses. They were noted for their piety and in this group he soon earned the nickname 'Angelical Thomas'. He frequently led prayers and delivered sermons, both of which he did in a powerful but somehow soothing and very attractive voice. He gathered around him a kind of unofficial congregation of worshippers, largely female, who found him charismatic and some of whom, dare we say it, probably fancied him something rotten. With a covey of followers of this kind, almost his every action came to be the subject of scrutiny and rumour. The advantage of rumours is that they are easy to invent but they are even easier to spread. One rumour concerned his stick, from which he seemed inseparable. He always held it when worshipping and

it was unquestionably a very fine specimen as sticks go. The buzz was that it had been imbued by him with a special power that allowed it to go for walks by itself. Before long, his witless admirers were full of their tales of encounters with this stick when it was out on one of its solitary jaunts.

Therefore we have a man who gained a reputation for model sanctity and piety and it was understandably something of a shock when a complaint was made about Weir by a girl from Lanark. She averred that he had not only made a number of lewd suggestions to her but he had touched her in places where he shouldn't have, at least without her permission. Everyone knew that this was totally out of character and the accusation was contemptuously dismissed. He was publicly described as 'more an angel than a man' and she, for her temerity in bringing the accusations, was whipped through the streets.

Something ought to be said about Jean, Weir's sister. She remained a spinster all her life. She had once kept a school at Dalkeith. In that district it was widely thought that she had special powers that enabled her to communicate with the fairies but this was seen as a beneficent and not in any way a harmful ability. When, later in life, she joined her brother in Edinburgh, it seems that she was prepared to allow him to have the limelight.

Weir undoubtedly enjoyed being the cynosure of a narrow but devoted circle of acolytes who hung on his every word. He developed the reputation of being extraordinarily erudite on the scriptures and on spiritual matters. He became the male equivalent of an agony aunt and people sought out his advice on all manner of moral and ethical matters. He was quite unstinting with this advice and offered it to all and sundry but in strictly devotional matters he associated only with the members of the Bowhead Saints. He used to preside at a kind of court consisting of the Saints where he led the prayers and held forth, throwing crumbs of extraordinary insight and wisdom to his awestruck following, some of whom seemed to worship his every word and move.

In 1870 the cosy little comfort zone of these people was rudely shattered when Weir used one of these 'audiences' to make an announcement which absolutely stunned all who heard it. He had invited a select group of his followers to a meeting after saying that he had an important admission to make. He was looking old and haggard when without a blush or even a twitch, he admitted to a lifetime of the basest depravity. He unleashed an avalanche of revelations about himself numbering incest, adultery and bestiality among the litany of cardinal sins in which he had taken part and in which he had revelled. He apologised because time, he said, only allowed him to provide the audience with a flavour of the sensuous and forbidden pleasures in which he had indulged over his lifetime. As one would expect, many of his audience swooned while others merely reached for the smelling salts as they listened, dumbstruck with horror – their illusions shattered in the space of a few minutes. The apple of their eyes had been revealed as having feet of clay although it wasn't what he'd done with his feet that they were concerned about.

Weir had really put the cat among the pigeons. The Bowhead Saints were in a difficult spot. They prided themselves on their exclusivity and on the standing they had in

Edinburgh's Protestant community yet here was their leading light revealed as a perverted sinner of the very basest ilk. Thinking quickly and with considerable savvy given the circumstances, they decided that the revelations must not go beyond those present who were all sworn to absolute secrecy. They kept Weir under virtual house arrest, telling any who asked, that he was severely ill. Unfortunately among the Saints who had been present during Weir's extraordinary confession, there was an ordained priest called Sinclair. He had long been jealous and resentful of Weir's dominant position in the sect and he wrestled with his conscience. He didn't wrestle for long and he duly took himself off to acquaint the Lord Provost about Weir's revelations. As expected, this grandee was stunned and he sent a team of doctors to examine Weir and to establish whether he was of sound mind. They confirmed that, although he was physically frail, there was no doubting his sanity. Weir told them that he desperately wanted to answer to the law for his lifetime of sin. Witnesses came forward with evidence that the authorities pieced together and which showed that over the years the behaviour of the brother and sister had by no means been as saintly as their public image had suggested. Most of these witnesses were women who under normal circumstances would not have come forward for fear that their testimony would not have been taken seriously or worse, it might have landed them in trouble.

Weir and his sister, with whom he claimed to have engaged in incest, were arrested and housed in the dreaded Tolbooth. She told the guards that Weir's famous stick or staff had magical powers and that if he was allowed to keep it with him in the cell, he would soon use it to enchant them. We've already seen how it had the ability to go for a solo walk when the mood took it but she revealed that it was actually much more multi-skilled than that. It gave Weir protection from earthly punishment no matter what base sins he engaged in and somehow it could also persuade God to ignore whatever transgressions and trespasses he was engaged in. It was confiscated.

Two officers of the guard returned to Weir's house and conducted a search where they found surprisingly large amounts of money, hidden away under piles of rags. They impounded the money and the rags. The latter were burned and such was the hysteria that was developing that it was said that the rags ignited, started swirling round as if alive and dancing and then, finally, they exploded.

All the big-wigs in the world of Scottish religion visited Weir in his cell while ignoring his sister as she was a mere woman. Although he was fast deteriorating physically, he was communicative and prepared to amplify and expand on the remarkable admissions he had made and his visitors homed in on these with prurient relish. He could not be persuaded to repent and cursorily dismissed their well-intentioned offers to pray for him. He explained that in 1648 he and his sister had found themselves in a fiery coach being whisked away to Musselburgh where they met the Devil with whom they proceeded to make a compact. It was never explained why the Devil chose Musselburgh for this rendezvous. It seems a pretty harmless place.

Brother and sister appeared in court on 9 April 1670. He faced a variety of charges concerning his sexual misdemeanours. She faced similar charges but in addition various indictments for sorcery and witchcraft. As previously explained, being a woman she was seen by her male accusers as potentially far more evil than any man could ever be. After all, they argued, all women had it in them to be witches and harlots. While she had been helping the authorities with their enquiries, it was claimed that they had found a Devil's mark in the shape of a horseshoe on her forehead.

Both were executed for witchcraft, necromancy, incest and anything else that could reasonably be thrown their way. Weir was strangled and burnt at the stake, a horrible way to go, at the Gallow Lee in what is now Leith Walk. His request to be accompanied by his stick was, perhaps surprisingly, granted and legend has it that as its master was immolated, it twisted and writhed as if in sympathetic agony. By this time everyone thought that the stick was imbued with the power of the Devil. Jean was hanged in the Grassmarket but not before she had launched an attack on the hangman on the scaffold and had seriously injured him by forcing his head through the rungs of the ladder and then stamping up and down on him. Modern thinking is that both Weir and his sister were completely insane.

The long-standing apparent saintliness of the couple combined with the revelations concerning the devilish activities in which they indulged guaranteed them a place deeply rooted in Edinburgh folklore and legend. The West Bow where they had lived was believed to be haunted by their spirits. Their house which became known as 'Major Weir's Land' was left empty for well over a century for lack of anyone who was prepared to live there, no matter how cheap the rent was. Stories circulated to the effect that the ghosts of the couple engaged in revels with a variety of visitors from the satanic underworld. Many people claimed to have seen these creatures of the night arriving or flitting to and fro as they went about their festivities inside the semi-derelict building. Music and devilish laughter was also heard, or so it was claimed. Lights were seen. Weir's magic stick found a new role for itself, displaying a talent nobody had previously suspected it of possessing. This was to act as the doorkeeper, only admitting those visitors whose credentials were evil enough to satisfy the stick's rigorous scrutiny. On occasions Major Weir was observed galloping up or down the West Bow on a huge headless horse which appeared to be on fire. If this was not bad enough, then it was also said that occasionally the Devil himself dropped in, arriving in a coach drawn by six jet black horses with fiery eyes. The ghost of the Major might be seen through the dusty windowpanes making ready to receive his honoured guest.

The house was actually empty from 1670 to 1820 in which year residents of the West Bow were amazed to see furniture and other possessions being carried in to the semi-derelict building. It had been rented out to a family by the name of Patullo who had been attracted by what was little more than a peppercorn rent for what was thought of as a property that could not be let. (Housing in Edinburgh was expensive even then). Nosy

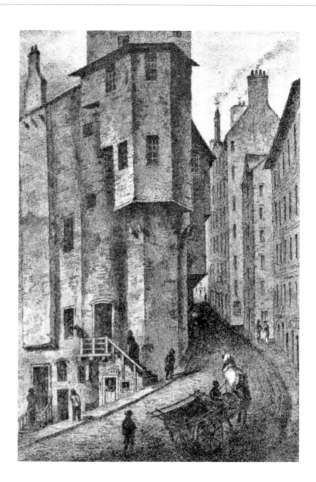

Major Weir's home in the former West Bow, now Victoria Street, which joins the Grassmarket to the Grassmarket.

neighbours posing as friendly neighbours sidled up to the Patullos and told them about the house's evil reputation. For their part the Patullos said that they knew all about the stories and thought that they were rubbish. They had only been there a few days before life was being made uncomfortable by objects being moved round invisibly and a variety of mysterious disembodied noises occurring. These phenomena were bad enough but worse was to follow when, in the middle of the night, a glowing calf's head appeared at the bed-end and then the rest of the animal placed its forefeet on the bed itself. Next day the house in the West Bow was to let again. The block of buildings of which it was a part was demolished in 1878.

CHAPTER 12

A Pot-pourri of Oddities

Margaret Dickson was a familiar sight peddling fresh fish around the city. In 1723 her husband left her. His timing was particularly inconsiderate because she had just given birth to the couple's second son. Totally financially bereft as the result of his entirely unexpected departure, she left her older son and the infant with relatives. Deciding to put these bitter memories as far behind her as she could, she intended to head south for Newcastle where she had friendly relatives. Perhaps she could make a fresh start there. She made her way as best she could, walking or travelling even more slowly but possibly more comfortably in lumbering carriers' wagons. She decided to stop over one night at an inn at Kelso, a small border town. She liked the place and, getting on very well with the landlady and her family, she asked if she could stay and work for them, living on the premises. This worked well for a while and she and Mrs Bell, the landlady, struck up a strong friendship. She struck up an even stronger friendship, albeit of a different sort, with Mrs Bell's son, William. It wasn't long before Maggie – which is what everyone called her – became pregnant as the result of sessions of impassioned rumpy-pumpy with young William.

He made it clear that marriage in the event of Maggie becoming pregnant was not what he had in mind on those occasions when they had slept together. There was little sympathy for the plight of unmarried mothers and so Maggie felt that she had no option but to hide the fact that she was expecting. She managed this with some difficulty but the child, who was born prematurely, died after a few days. Maggie, fretting about the death and also fretting about what would happen to her job if the birth was discovered, decided to throw the baby's inert corpse into the fast-flowing River Tweed. Understandably, she couldn't bring herself to do this and she decided to hide it in the reeds by the side of the river. Quite what she had in mind by doing this is not easy to determine.

The baby's body was found the same day and the man who made the discovery went straight off to the magistrates. In a small town like Kelso, it didn't take long before the dead infant was traced back to Maggie. The authorities moved quickly to arrest her. She was charged under the 1690 Concealment of Pregnancy act and was returned under guard to Edinburgh to stand trial. Her offence bore the death penalty. Maggie was tried, and when found guilty was sentenced to be hanged.

Maggie had been a familiar and well-liked figure on the streets of the Old Town and so large crowds of well-wishers turned out to support her on 2 September 1742 which was the day of her execution in the Grassmarket. Her friends had a cart and a coffin ready so that she could be taken away quickly and given a decent burial. Maggie was hanged, the attendant doctor announced the cessation of life and the body was then cut down by the hangman. Then pandemonium broke out. A substantial number of medical students had turned up intent on seizing the corpse of this young woman who had been fit and healthy until her demise. Her cadaver would make an excellent object-lesson for their studies of human anatomy. The crowd for its part was determined that she should be given a decent burial and a free-for-all broke out which ended with the students getting a good hiding and withdrawing, bloodied and in confusion. They had been routed. Nobody in Edinburgh liked them anyway.

Off jogged the cart bound for the village of Musselburgh just outside Edinburgh where Maggie was to be buried. It had been thirsty work and the funeral party decided to stop off at the Sheep Heid Inn at Duddingston, a temptation to which the authors have often succumbed although, they are anxious to point out, not in the company of a corpse. Something of a wake was held and many of the participants were in their cups after a couple of hours serious drinking. Somehow or other they were persuaded to continue on their way and were not far from Musselburgh Kirkyard when a series of muffled moans and groans was heard emanating from the coffin. The members of the party sobered up extremely quickly and prising open the coffin lid, found to their astonishment that Maggie was alive and, if not exactly kicking, was at least definitely *compos mentis*. Initially somewhat flummoxed by this turn of events, they then debated what to do and decided that she should be returned to Edinburgh. Now it was the turn of the authorities not to know what to do. The greatest legal, philosophical and religious brains that Edinburgh could summon as well as the Edinburgh Town Council, pondered and debated long and hard on the issue. Should she be hanged again?

Finally they agreed that since death had been pronounced by mere humans but that she had not actually died, then this was clearly an act of God who did not intend that she should die. For this reason Margaret Dickinson was reprieved. She lived in Edinburgh for almost another half-century and enjoyed the celebrity that went with her nickname of 'Half-Hangit Maggie'.

TALES OF A MUSIC BOX

Coates Crescent stands on the north side of Shandwick Place in Edinburgh's West End. In 1850 a resident of the Crescent went away only to find on his return that his place had been burgled and that many items, some rather more of sentimental than cash value, had been stolen. Most of them were of low grade gold and silver which meant that they were

easy to dispose of by being melted down. Probably the most interesting, although by no means the most valuable, item that had been stolen was a small musical box which played *The Blue Bells of Scotland*.

The detective assigned to the case was James McLevy, an enormously shrewd and experienced officer with just the right amount of serendipity. He had the reputation of being lucky where others had failed. Even he was beginning to think not so much that the trail had gone cold but that there had never really been a trail at all when he found himself wandering down the now long-gone Blackfriars Wynd. This was an area where villains often consorted and he himself was well-known and grudgingly respected in the area. He was thinking about nothing in particular when he passed a wee howff to hear the familiar tune *The Blue Bells of Scotland* being rendered in the tinkling fashion of a musical box.

He entered and the landlady told him that one of her regulars had brought it in to show off but had obviously forgotten it when he left.

The landlady was understandably guarded about the identity of the regular but McLevy had an intimate knowledge of the villains (he called them 'bairns') who inhabited his patch and he made his way to the tenement flat of his hottest suspect. He rapped on the door – he had a distinctive and stentorian rap of the sort that could not be ignored – and, having gained admittance, found both the gang of thieves responsible for the Coates Crescent burglary and the stolen items. The gang members stood trial and were sentenced to transportation to Van Diemen's Land – out of sight, out of mind.

James McLevy was a policeman of the old sort. Of Irish extraction, he migrated to Scotland and joined the police force in Edinburgh. Over a long career, he became close to the people and the streets of the city, developing the immense know-how and wisdom of their ways which could only be gained by endlessly pacing those self-same streets and peering into every wynd and court. He knew his people and was a policeman of the community.

The Last Public Hanging in Edinburgh

On the south side of the old High Street, part of the tourist trap known as the Royal Mile, close to the junction with the street known as George IV Bridge, set into the pavement are three brass rectangles shaped like a letter 'H'. Standing at the entrance to the former Liberton's Wynd, these brass insets mark the site of the last public hanging in Edinburgh. This took place on 21 June, 1864 when George Bryce was hanged for murdering a young nursemaid.

Bryce seems to have been a rather uninspiring and unexceptional young man who worked for his father who had a smallholding and a pub in the village of Ratho, west of Edinburgh. Physically plain of appearance and bland of personality he may have been but

he had become the lover of a young woman employed as a cook by a family called Todd who lived in a substantial house overlooking the village. Another servant in the house was Jane Seaton, employed to look after the small children. For undisclosed reasons she took an immense dislike to Bryce who visited the house regularly albeit in a clandestine fashion, She was suspicious of his character and motives. Jane was a forceful woman who expressed her feelings so vehemently that the young cook decided to end the relationship with Bryce. Another factor that may have assisted the cook in her decision was the fact that in those days, female servants risked instant dismissal if they were found to have what were euphemistically known as 'followers'.

Bryce blamed Jane for wrecking his relationship with the cook and he took to stalking her. He hung around the garden of the big house in a menacing fashion gesticulating at Jane if he managed to catch sight of her inside. On one occasion he even tried to gain entry through a window. Bryce appeared in all weathers although quite what he hoped to achieve by doing so was unclear at first. It became clear that it was vengeance on Jane that he had in mind because early one morning and armed with a razor hidden in his pocket, he made his way to the big house. He managed to attract the attention of his former girlfriend who answered in the affirmative when he asked her if Jane was in the house. She told him in no uncertain terms, however, that on no account was he to enter. He shoved her aside unceremoniously and he rampaged around the building until he came across Jane in the nursery. He attacked her, threw her to the ground and attempted to strangle her. She screamed and the commotion brought others to the scene. They managed

At the top of Liberton Wynd in Parliament Square, the last public execution in Edinburgh took place in 1864. The site is marked by these setts and brass inserts.

The brass inlays marking the site of Edinburgh's last public execution.

to restrain Bryce while Jane fled. Bryce wriggled free and set off in hot pursuit. He caught up with Jane some distance away, pulled her to the ground, slashing at her with the razor and killing her instantly.

When the case came to court, it attracted massive interest. Although the case against Bryce seemed cut and dried, the authorities expected vast crowds to turn out to witness his execution. For this reason they decided to carry out the sentence at eight in the morning. By six in the morning every possible viewing point was occupied by a crowd avid for entertainment. Since the erection of the gallows had begun at about two-thirty in the morning, accompanied by the usual hammering and banging, it is hardly surprising that the seeds of expectation had been sown and that the High Street was en fete with the sellers of pies and other comestibles doing a roaring trade. It was the usual gallows crowd containing many prurient voyeurs all too eager to vent their spleen on the criminal but as was so often the case, it was a democratic assembly in the sense that women and children were there in plenty as well as many from the well-to-do sections of Edinburgh society. It was a drunken and boisterous mass of humanity for whom the entertainment started when the gallows was being erected in the early hours of the morning.

The better-off inhabitants of the High Street literally had grandstand views since many of them lived on the top floors of the high tenements or lands. Some even charged expensive fees for the public to come and share the view. Bryce was hanged at 8 in the morning and at 9 his body was cut down. It was removed to Calton Jail for burial. It is impossible to say whether the massed crowds on that occasion were there out of a determination to see a brutal killer pay the price for his crime or because they were aware of the historical nature of the occasion – the last public hanging in the City of Edinburgh.

THE STOCKBRIDGE BABY-FARMER

Stockbridge is a fashionable and prosperous part of Edinburgh just to the north of the New Town which over the years has housed many artists, literary figures and intellectuals. There was, however, nothing very fashionable or intellectual about Jessie King, often referred to as the 'Stockbridge baby farmer'. She was executed in Calton Jail on 12 March 1889, the last time a woman was hanged in Edinburgh.

As with so many of Edinburgh's nineteenth century underclass, little is known about Jessie's early years. In May 1887 she is recorded as living in the Dalkeith Road area with a man called Pearson. It was a bit of an up-and-down sort of a relationship but no worse than that of many others who spent a lifetime in poverty. In November of that year, she saw an advertisement seeking an adoptive home for a baby boy aged five months.

The baby was Walter Anderson Campbell who had been born at Prestonpans on 20 May 1887, the illegitimate offspring of Elizabeth Campbell and one David Finlay from Leith. Elizabeth died shortly after Walter was born and her sister then took care of the infant but found it a struggle and in conjunction with Findlay decided to try to get him adopted. Jessie approached them with a sob story about having just lost a baby of her own. The deal was quickly done. Finlay paid Jessie £5 and the child now belonged to her.

The baby seemed to be doing well in his new surroundings and Pearson had apparently grown very fond of it. He was surprised therefore, and not a little put out, when he came back from work one day to find that wee Walter was nowhere to be seen. Jessie then told him that she had grown tired of him and arranged for him to enter an orphanage, 'Miss Stirling's', located not very far away in Causewayside. She invented a very different story for the neighbours, however. She told them that she had only been looking after the baby temporarily and had now returned it to its mother, who was her own sister. Pearson seemed slightly put out when Jessie told him that it was not usual for 'fathers' to be allowed to visit their children in the orphanage. It is surprising that he was unaware that there was no orphanage in Causewayside. Miss Stirling's Home for Orphans was actually in Stockbridge. Meanwhile baby Walter had been done away with.

Catherine Gunn was an unmarried maid who, in 1887, gave birth to two healthy twin boys, naming them Alexander and Robert. Bringing them up on their own was a virtual impossibility and she lodged them with a foster mother. When she found she could not keep up with the payments for their care, she decided to advertise them for adoption. By this time Jessie and Pearson had moved across the city to Stockbridge where they now chose to be known as Mr and Mrs Macpherson. Jessie answered the advert and obtained Alexander plus £3 for her trouble. Jessie worked in a laundry but was lucky enough to find a steady young girl living nearby who was happy to look after Alexander during the day in return for a few farthings. She grew fond of the infant and was most put out when Jessie explained to her that Alexander's father had decided to look after him so her services would no longer be required. A few weeks later, Catherine, Alexander's real

mother, came to see him as she had done a few times before and was quite distraught when she found that the 'Macphersons' had moved away without giving any forwarding address. They had actually moved to an address in Cheyne Street, not far away. Alexander disappeared without trace. Few questions were asked.

Violet Tomlinson was a hapless wean born in August 1888. Her mother was unmarried and the child was looked after on a short-term basis by its grandmother. The usual advertisement was placed. Jessie must have been on her uppers by now because this time she received just £2 for the privilege. Violet spent little time in Jessie's custodianship and was almost certainly dead by October 1888. Again, this seems to have excited little curiosity in the underbelly of Edinburgh society. Never keen to involve the police in such matters, it seems that they regarded the disappearance of babies as one of those things that just happened. Even the natural parents of such infants rarely seem to have made a great fuss. Their lives were hard enough as it was.

However, Nemesis was about to strike. It did so in Cheyne Street on the afternoon of 26 October 1888. Some street urchins had found a bundle wrapped in waterproof material and appropriated it for use as a football. The wrapping got some hard treatment and worked loose. Two of the boys, with the intention of fixing it so that they could continue their game, picked it up. Curious to see what was the fairly solid object inside which gave the package its weight, they unwrapped it, revealing the severely decomposed body of an infant. This nauseating revelation could not be kept in the community and the police were informed. Examination of the corpse suggested a boy child aged about one year who had probably been strangled.

The police started their enquiries and it did not take them long to bring 'Mrs Macpherson' in for questioning. A search of the Cheyne Street premises revealed the bodies of a boy and a girl, both babies. The female child at least, had been strangled. Jessie was arrested and charged with the murders of Alexander and Violet and brought to trial at the High Court of Justiciary on 18 February 1889. The proceedings lasted only a few hours and the result was almost a foregone conclusion. Shortly afterwards Jessie King was hanged. The case rocked the complacency for which Edinburgh was somewhat noted. Some people thought her crimes made her the absolute dregs of criminal society. Others felt sorry for the dire financial circumstances that led to the offences and pointed out that she would not have committed the murders had there not been parents so heartless or so straitened as to resort to selling their own offspring. Some were horrified that such things could happen in Stockbridge.

'Antique Smith'

Edinburgh has always attracted bibliophiles. Even today the city has several fine second-hand book shops. In the 1880s there were numerous such shops on George IV Bridge.

Flippantly it could be said that those who inhabit second-hand book shops fall into two categories. Firstly, because they stand out, are the bombastic loud-mouthed bores holding forth to anyone who will listen, desperately trying to be thought of as erudite 'characters' and failing abysmally. Second, and thankfully more numerous, are the inconspicuous, generally slightly dishevelled and more nerdish patrons of the kind whose day (and week) is made when they find an almost mint first edition of such works as Tompkins' *Fruit Bats of Madagascar*, published in 1853.

Such a nerd haunted the shops on George IV Bridge, keeping himself to himself but always on the look-out for obscure and old tomes in fine bindings. These he bought in large numbers. They were often cheap – just the kind of dead stock no one else would want. His choice of titles was eclectic. This is not surprising – he did little reading. The dealers knew him of course. They may have thought he was just another eccentric. In fact he was a forger of extremely high-class literary and historical documents. Most of these related in some way to the past of Scotland and included forged items such as 'correspondence' by Burns and Sir Walter Scott. He even produced 'new' poems by Burns. His output was good enough to have been bought by well-to-do and discerning collectors of such material.

Alexander Howland Smith had many enjoyable years producing these spurious documents and manuscripts and it is likely that he derived his pleasure more from the craftsmanship involved and the duping of the self-appointed connoisseurs than from pecuniary gain. As a person he was undoubtedly a little odd. His friends called him 'Antique Smith' because of his love for ancient books and documents. His output was prodigious and the problems began when dealers who had bought his material in good faith tried to sell items on to collectors and experts. An absolute storm arose, for example, when some of the poems by Burns which had been bought by an expert were published in a literary review. Bitter debates took place between those who accepted such material as genuine and didn't want to be shown up for having bought a forgery and those who were convinced that the material was spurious. The details of this wrangling need not concern us except to say that doubts had been sown. As more and more of these items came to light, so the matter came to be taken increasingly seriously. Reputations of individuals were at stake but so was Scottish national pride.

In 1892 the *Edinburgh Evening Dispatch* put its best investigative journalists onto the job of establishing the truth. Articles were published in the newspaper showing what were believed to be forged letters in a portfolio recently bought by an Edinburgh dealer. A reader contacted the reporter. He told him that the handwriting on the letters bore a very close resemblance to that of a man who he occasionally employed as an amanuensis. The reporter rushed round to the address he had been given and interviewed Smith who quite calmly owned up to having produced thousands of forged items. There was a certain pride in his demeanour as he did so. Perhaps he hadn't realised that he was soon going to be in a great deal of trouble.

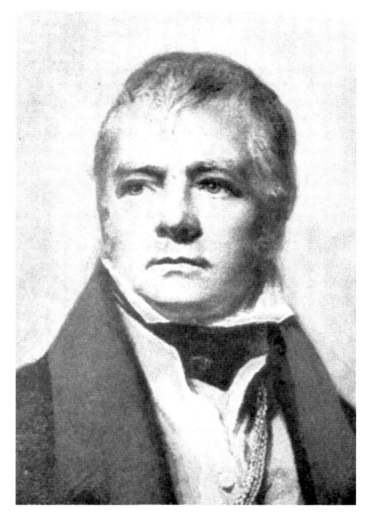

Scott (1771-1832)
lived at No.39, North
Castle Street from 1802
and 1826 and was the
extremely prolific author
of historical romances
bearing only the slightest
resemblance to events
that ever actually
happened. One of them,
Waverley, *gave its name*
to the city's main railway
station and a very fine
name it is too.

On 26 June 1893 Smith appeared in court charged with 'fabricating manuscripts or other documents of apparent historic or literary interest' and fraudulently obtaining money by selling them as genuine. It emerged in court that while some of the forgeries were of very high class, others were highly amateurish. One for example was on a piece of paper with worm holes, presumably 'proof' of its antiquity but the writing went round the holes rather than being punctuated by them. He was found guilty and was sentenced to just twelve months imprisonment but there were certainly some red faces among the so-called cognoscenti of Scottish literature. Perhaps Smith obtained some satisfaction from knowing this.

SMALL-TIME FORGERY

Two men who were as Edinborian as the rock on which the castle stands appeared in the High Court in 1930, pleading guilty to several charges of counterfeiting. The authorities have always taken an extremely jaundiced view of those who make or knowingly pass counterfeit money. Coins nearly always carry the image of a sovereign or a head of state or at the very least a well-known patriotic symbol. Governments believe that money, if it is to do the job required of it, must be inviolable. Producing counterfeit coinage is regarded as not merely defrauding a few individual citizens, which is bad enough in itself, but is thought to be especially heinous because it undermines the financial integrity of the nation.

James Steele and Robert Ramsay shared a flat at 13 Caledonian Road off Dalry Road, then as now an area not featuring largely on the Edinburgh tourist's radar. They were joiners by trade and had a workshop close by in bleak Murieston Crescent Lane. They didn't do much joinery or even the wireless repairing which was another string to their bow. Instead the workshop was largely given over to the manufacture of counterfeit coins of very high quality.

That Steele and Ramsay ended up spending time at His Majesty's Pleasure was due to the extraordinary vigilance of a lady working in the sub-post office at Elm Row, Leith Walk. Her name was Miss Tennant and she became suspicious of a small boy who regularly bought postal orders, always tendering half-crown coins for them. An unusually large number of these bore the date '1920' and seemed in very pristine condition given that they were ostensibly ten years old. In particular the milled edges were particularly well defined. The bank assured her that they were genuine but, not being satisfied, she took samples to the police. She had to work hard to convince them to take the matter seriously but eventually, if only to shut her up, they asked experts who told them unequivocally that the coins were fakes.

The police kept watch on the post office and followed the boy the next time he bought a postal order. He was seen to hand the postal order to a man at nearby Union Place. The man was Steele. He was not co-operative but it wasn't long before the police visited the flat in Caledonian Road where they found many more counterfeit coins and the dies necessary for their manufacture. The run-down workshop in Murieston Crescent Lane yielded further evidence.

They were sentenced to three years each. On gaining their freedom, they disappeared back into the obscurity which was their lot in life but the sequel is interesting. Steele in due course moved back to 13 Caledonian Road. In 1964 when he was eighty, he opened the door to the police were who following up complaints about noise in the neighbourhood. In a moment of absent-mindedness he let them in unintentionally revealing large amounts of coin-making equipment. He was charged with having manufactured 14,000 florins or in today's language, ten pence pieces. He went to court and this time picked up a two year

sentence. Everyone concerned with the case commented on the superb workmanship of the counterfeit coins. The old man simply couldn't stop himself!

WILLIAM MERRILEES

No look at crime in Edinburgh would be complete without a brief mention of the man who is probably Edinburgh's most famous police officer. William Merrilees was born in a Leith slum. He had no education to speak of, was under the required height and was missing two fingers on each hand but this did not stop him from applying to join the constabulary and becoming a constable in 1924. He went on to display an extraordinary talent for disguise, for undercover work and for following suspects without their knowledge.

One of the stories told about him verges on the fantastic. A flasher was at large, revealing the bits of him that he shouldn't to a succession of female victims, all of whom naturally found the experience highly distressing. Merrilees was put on the job and decided to go undercover. The covers he was under were blankets in an old-fashioned carriage-built perambulator. He was disguised as a baby and was wheeled around the area where the incidents had been occurring. He was sufficiently well disguised not to attract attention. His patience was rewarded when the flasher flashed and Merrilees leapt out of the pram dressed, literally, in nappies and pursued the pervert across several hundred yards of park before arresting the bemused man.

He infiltrated the murky world of the city's shebeens or illegal stills and drinking places and his investigations led to many prosecutions. He then turned his attention to the even more louche and sinister matter of prostitution. At the time there were many child prostitutes soliciting for business in the area around The Mound. Some of these children were only twelve or thirteen. His efforts removed these poor unfortunates from the streets and led to many of their pimps going to prison.

He ruffled many feathers when he got behind the scenes at the Kosmo Club. This was a well-known rendezvous in the West End in which a dance hall was the front for a sophisticated and highly organised sex business. The services offered by its 'escorts' were advertised on local newspapers which somehow managed just to stay within legal requirements. Anyone who followed up the advertisements would have found that every sexual taste and proclivity was catered for, some of which would most certainly have been outside the law. Merrilees pursued his enquiries in his usual dogged and thoroughgoing way. He revealed that many apparently respectable organisations made extensive use of the club's girls for office parties. There were some red faces at the Chamber of Trade as Merrilees made his report. Less expected were the revelations that working girls from the Kosmo visited nursing homes in and around the city. It is to be hoped that they put the lead back in the pencils of the often elderly residents. The Kosmo Club could not survive such publicity and it closed down. Merrilees of course knew that its business would simply continue elsewhere and under different names.

In the Second World War Merrilees masqueraded as a porter on Waverley Station and trapped a man suspected of being a German spy. He had the uncanny ability to make people take him into their confidence and over a period he befriended this rather naïve man and eventually listened as he told him, in confidence, that he was a spy. Merrilees went on to become a very senior police officer.

Also available from Amberley Publishing

Glencoe
The Infamous Massacre 1692
John Sadler

ISBN 978-1-84868-515-4
£12.99 PB

Available from all good bookshops or order direct
from our website www.amberleybooks.com

Also available from Amberley Publishing

The Last of the Clan
General Roderick MacNeil of Barra, 41st Chief of the Clan MacNeil

Keith Branigan

ISBN 978-1-84868-431-7
£16.99 PB

Available from all good bookshops or order direct from our website www.amberleybooks.com

Also available from Amberley Publishing

Scottish Ghosts

Dane Love

ISBN 978-1-84868-722-6
£12.99 PB